CHORLEY BOROUGH

THROUGH TIME

Jack Smith

AMBERLEY PUBLISHING

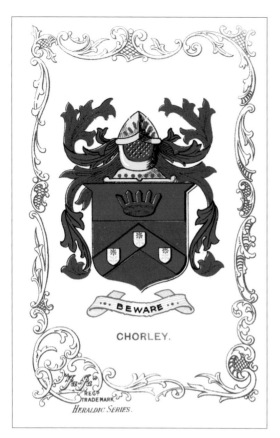

Chorley's Coat of Arms
The Borough of Chorley was granted its
Charter of Incorporation by Queen Victoria
in 1881. It adopted the heraldic Coat of Arms
of the Chorley family of Chorley Hall, whose
roots lay back in the thirteenth century.
The town motto, chosen later, was 'Beware'.
However, in the twenty-first century the town
council decided that a more 'up to date' motto
should be selected, and it was changed to
'Be Aware'. Similarly, the Chorley Borough
Council dropped part of its name to become
simply 'Chorley Council'.

First published 2012

Amberley Publishing
The Hill, Stroud
Gloucestershire, GL5 4EP

www.amberley-books.com

Copyright © Jack Smith, 2012

The right of Jack Smith to be identified as the
Author of this work has been asserted in accordance
with the Copyrights, Designs and Patents Act 1988.

ISBN 978 1 4456 0276 9

British Library Cataloguing in Publication Data.
A catalogue record for this book is available from
the British Library.

Typeset in 9.5pt on 12pt Celeste.
Typesetting by Amberley Publishing.
Printed in the UK.

Introduction

Chorley is located to the eastern edge of the Lancashire Plain, with mainly flat agricultural land to the Irish Sea coast to the west, some twenty or so miles away, while to the east the Pennine Hills rise to 1,100 feet above sea level. The local moors, Withnell, Anglezarke and Rivington are often considered to be a good place for a 'breath of fresh air, as the wind mainly blows in from the coast to the west.

Between the town and the moorland is a hill of some 400 feet or so. This is Healey Nab, sometimes known as Chorley Nab. This hill saw occupation in prehistoric times, and may also have been in use in the Roman period!

During the twelfth and thirteenth centuries, the area became part of a Royal Forest that extended from Bowland in the north to Bolton in the south. The area closest to Chorley was called the Royal Forest of Healey. Local place names still in use today echo this historical association with the forest. One example is that of Bagganley, from 'Bagin Ley'. Here was the largest of Chorley's (and Lancashire's) cotton spinning and weaving mills, built in the early 1900s. Its official name was Talbot Mill, most likely after the hunting dogs that were used in the forest. Close to the mill was a small seventeenth-century manor house, latterly a farm, called Bagganley Hall. In the fifteenth century this was the home of the Parker family, a name that again was associated with the park's maintenance and security etc. Sadly the hall was demolished with the coming of the M61 motorway in 1969.

Between town and nab is the valley of Black Brook (originally 'Bagin Brook'). Within this valley, passing from north to south, is the canal, originally built by the Lancaster Canal Company in the 1790s. The northern section ran from Lancaster to Preston, and the southern section ran from Clayton in Chorley to the Wigan coalfields. The mid-section between Preston and Clayton was linked by a temporary horse-drawn railway from 1803 to the 1860s. In 1816, the Leeds to Liverpool Canal Company, who had cut their canal from Leeds to Whittle Springs in Chorley and intended to continue via Wigan to Liverpool on a separate route, negotiated with the Lancaster Company and leased the Chorley to Wigan section, so no new 'cut' was needed.

The canal and its port of Botany Bay, an isolated community 2 miles from Chorley Town, provided residents with work, as did the increasing number of cotton mills in the later nineteenth century. This led to a population increase over the century from 3,307 people in 1815 to 26,852 in 1901, when some 17,900 looms and 500,000 spindles were in use in the mills of the town. Work was also plentiful in local coal pits, iron foundries etc.

The railway arrived in Chorley in 1840, having been cut from Bolton to Hoggs Lane, where a construction camp was set up to build Black Brook Viaduct. The railway was pushed forward into Chorley itself in 1841, where a terminus was built on Railway Street. This was in use for two years or so until the tunnel was cut at Hartwood. The railway was completed in 1843, when the route from Bolton to Preston was finished. In 1869, a Wigan to Blackburn Railway line was built running via Chorley, necessitating a splendid viaduct of eight arches over the canal at Botany. This was demolished in 1968 when the M61 motorway was built.

The largest Royal Ordnance filling factory in the country was built at Chorley between 1937 and 1939. Opened by King George VI and working until 2002, it is now demolished except for admin buildings and the new Buckshaw Village is developing on the site. I was co-author and adviser on the book *A History of ROF Chorley*.

Over the last fifty or so years, a huge amount a housing development has taken place on green land and the countryside is no longer as accessible. Ribbon housing along the roads is sadly commonplace and some garden spaces have been sold for house plots. The town has also lost a huge amount of its heritage in the form of buildings, from timber-framed houses to architecturally pleasing decorated cotton mills. A completely unique feature on the rail network at Hartwood Cutting, the sixteen stone arches erected in 1843 were allowed to be removed in 2009, with a proviso they would be re-erected within two years. That seems to have been forgotten!

In my role as industrial historian and recorder I have witnessed close hand the demise of almost every mill within the Borough of Chorley over the past thirty years or so. The last working mill in the town, albeit working with man-made fibres, was Lawrence's, which closed and was demolished in 2011. On its closure, I was given the very last Lancashire Loom shuttle used in Chorley.

Fortunately we have many 'goods' along with the 'bads'. We have a new country park at Yarrow Valley and a monument in the shape of the 150-foot mill chimney being saved from demolition to be used by Morrison's Supermarkets. I was involved with both these projects as historical advisor. Our famous markets have seen investment and improvements, and the pedestrianised streets find favour with shoppers. The new bus/railway interchange is much more convenient to users.

Sadly, we lost the statue of Benjamin Disraeli, Chorley's only statue. But we have since gained a new statue of a First World War soldier, commemorating the 'Chorley Pals' men who did not return.

Jack Smith
2012

CHAPTER 1

Turnpike to Trunk Road

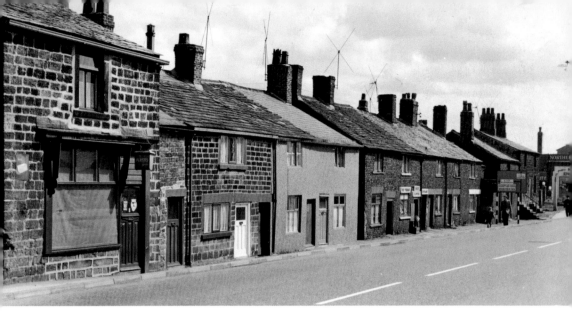

Turnpike Cottages

This row of stone-built nineteenth-century cottages, some rebuilt in brick, was occupied by workers of the cotton mills that towered behind them. The turnpike road ran through the town from Preston in the north, along the road at Hartwood Green shown on the previous page. The toll-house was that to the extreme left of the photograph. The row of cottages was demolished in the 1970s and the site is now occupied by a Comet store.

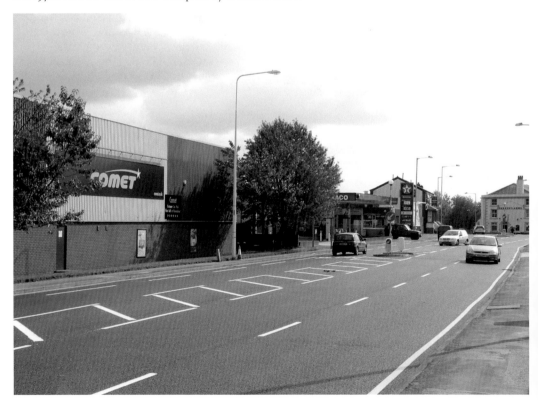

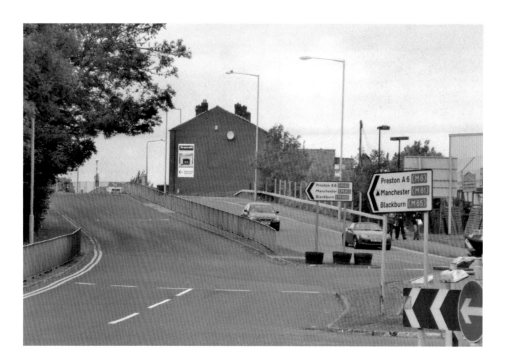

Preston Street

After passing Turnpike Cottages, the road dipped sharply down Preston Street to Water Street, where more stone-built cottages, dating from the early/mid-1800s and associated with the cotton mills, formed a three-sided block with an open courtyard in the middle. By the 1950s the site of the cottages had become a scrap yard (a great attraction for us as young boys then) and later, in the 1980s, Chorley's ambulance station was here. The mills behind the cottages were demolished in the 1990s and a retail park was built. The new right-hand carriageway and a B&Q store garden department are where the cottages once stood. The River Chor is culverted below the road, to the right of the picture.

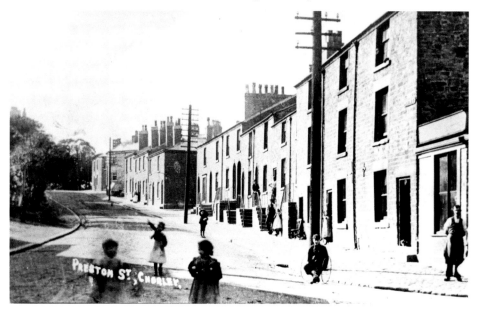

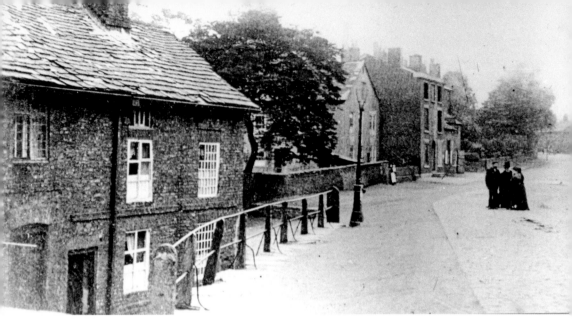

Water Street

In this 1880s view looking north-east towards Preston Street is the appropriately named Water Street at its lowest point, hence it is known as 'Chorley Bottoms'. The cottages to the left were 7 feet below street level and just slightly below the cottage floors was the River Chor. It had once flowed at street level, where stagecoaches would ford the stream when descending or climbing Church Brow. Close by was the old entrance to Astley Estate, before the building of the great Park Road embankment in 1820–1822. The cottages were replaced in 1900 by a row of new terraced houses; these too were demolished in the 1980s, to be replaced by a new Georgian-style building housing the Inland Revenue Offices.

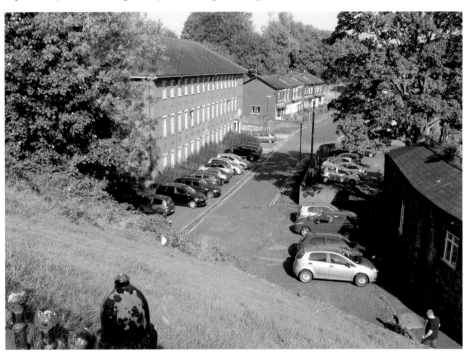

Church Brow

Just as the turnpike road dipped down into Water Street so too it climbed steeply up again at Church Brow, by the fourteenth-century parish church of St Laurence. The old graveyard dropped away so sharply to the roadway that a retaining wall was built in the nineteenth century. Townsfolk living to the north of the church used the doorway entrance seen in the wall. In around 1820 a large embankment was built across the valley of the Chor, eliminating the steep route through Water Street. Traffic improvements in 1964/65 widened the embankment road (Park Road) and Church Brow was partly filled in, becoming a footpath only, with a steep, grassed embankment where the carriageway once was, as shown in the present day view.

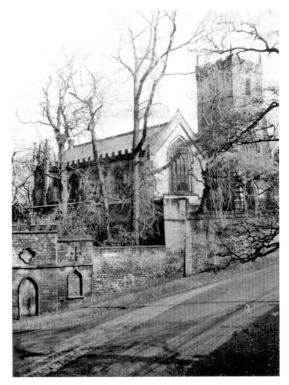

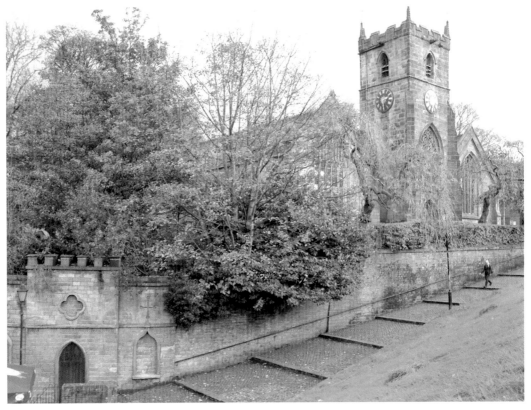

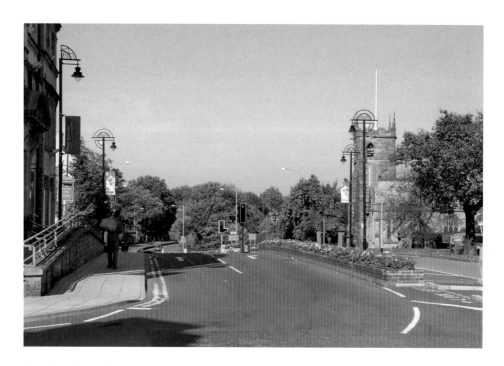

Chorley's First Town Hall

From 1822, having reached level ground at the top of Church Brow, the turnpike road passed in front of a stone-built building with colonnade giving access to a butter market for farm produce. The upper floor was used by the town's governors and police. The old town hall was superseded in 1879 when the new town hall was erected opposite, on the former site of one of Chorley's coaching inns. The new town hall is visible to the left in this 1920s view. The original town hall was demolished in the mid-1930s. None of the buildings to the right remain; they were demolished for road widening schemes in 1937/38. Today there are three carriageways at this location.

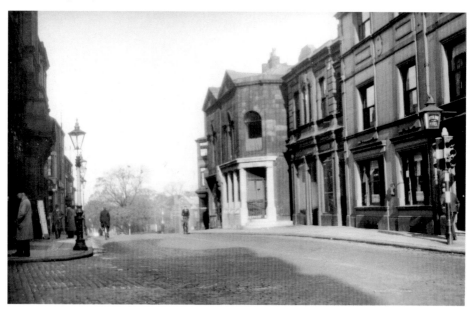

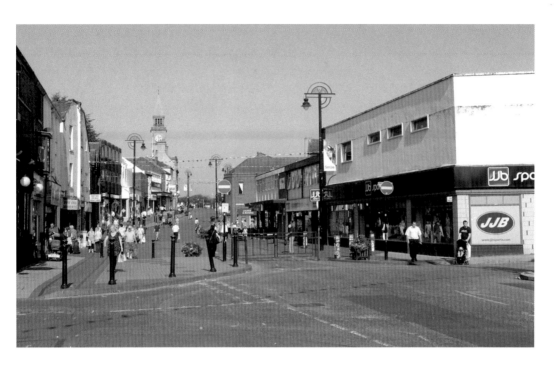

Market Street

The old route through the town passed where markets and animal sales were held from the seventeenth century. This 1890s view shows single-storey thatched cottages, probably dating from the early 1800s, and looks north-west to the 1879 town hall, which is just visible above the cart on the picture's left side. Close by is Parson's Brow. The end of St George's Street is visible on the right. Today's Market Street is quite changed; its shops are all rebuilt and it is partly pedestrianised. Limited traffic now passes through since a new town centre bypass was completed, becoming the new 'A' road.

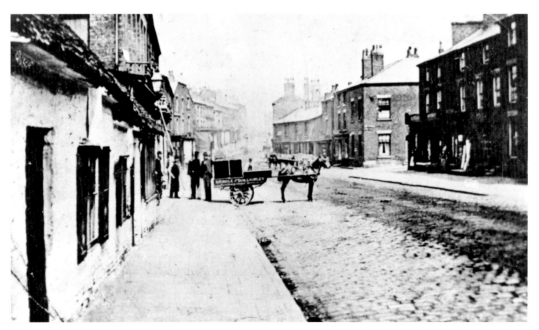

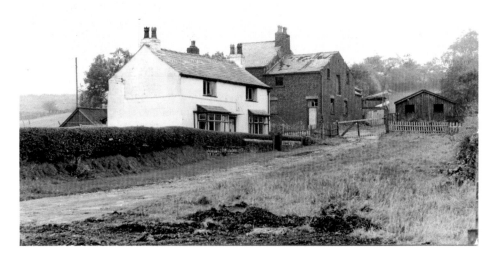

Red Bank

After passing through Market Street, Bolton Street and Bolton Road, the turnpike road veered south-west towards the Duxbury Hall estate land, where the gradient of the road gave coaches a steep descent to the inn close to the River Yarrow. The road crossed the river over a single-arch stone bridge to climb uphill again across Duxbury Hall estate. Then it passed via Wigan Lane and Rawlinson Lane to the toll-house at Nightingales, to continue towards Bolton. The isolated farm, shown in the old view, had associations with the Turnpike Trust and Yarrow Bridge Inn, supplying stabling and provisions for horses.

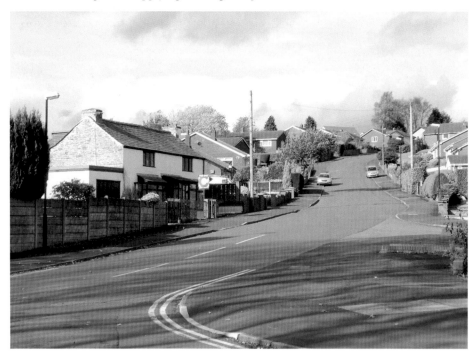

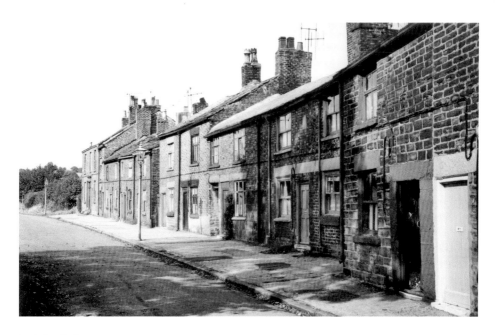

Red Bank Cottages

Looking south, past the mid-nineteenth-century stone-built cottages and a later row of brick houses built for employees of the nearby Duxbury Colliery. The trees in the distance are in the valley of the River Yarrow. The original Yarrow Bridge Hotel was on the Chorley side, close to the river crossing. It hosted Thomas de Quincey in 1820, while he was writing his infamous *Confessions of an English Opium-Eater*. Coach horses were regularly changed at the inn, and passengers often stopped for refreshment. Departing the hotel, the road crossed Duxbury estate land to the turnpike toll-house, which remains today. Today at Red Bank, modern houses are set back from the road, built on former colliery railway sidings. The old terraced house fronts stood where the wooden fence now encloses the new house gardens.

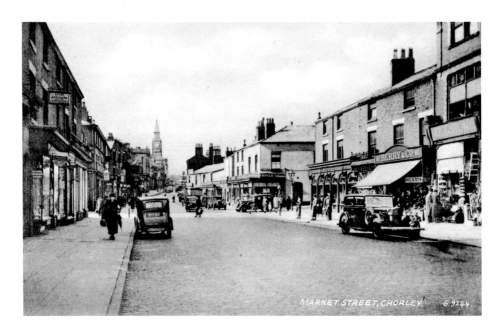

MARKET STREET, CHORLEY. G.9144.

Return to Market Street

The opening of Park Road in 1822 was almost coincidental with the closure of the old turnpike route from Rawlinson Lane via Duxbury estate to Red Bank. The new route began from Bolton Road, running due south and crossing the River Yarrow close to Hoggs Lane. A new inn was built and the road continued up the more gradual hill to pass Wigan Lane in the direction of Manchester and Bolton. Coaches now travelled along Park Road, bypassing Water Street. However, Market Street remained unchanged, except for new buildings. By the 1920s it had become the main shopping street, with many established family businesses. Today, the street is partly pedestrianised. While the shop buildings have changed little, their occupants have, as have some of the items now sold.

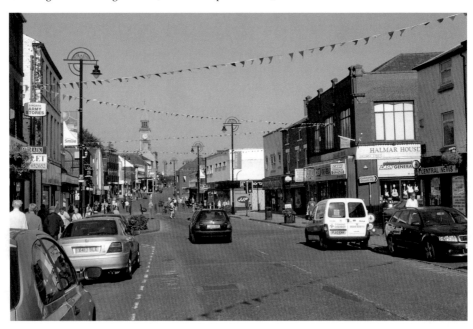

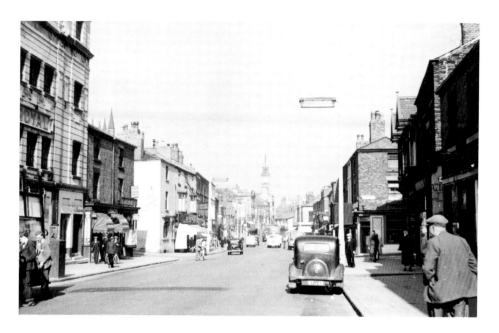

Market Street in the 1950s

I was one of hundreds of townsfolk who waited for Chorley's first electric neon strip street lights to be switched on in 1954 when, as the local press claimed 'Night was changed to day'. In this 1955 picture the Town Hall clock tower is visible in the distance and on the near left is the original 1911 Theatre Royal, having become a cinema boasting two balconies. The upper balcony was known as 'the monkey rack'. By 1955 the cinema had already lost its entrance and footpath canopy. Following the cinema's demolition, Chorley's first supermarket was built on this site. The supermarket later became a McDonald's restaurant. The whole of the site (just off the left edge of the photograph) is currently awaiting redevelopment.

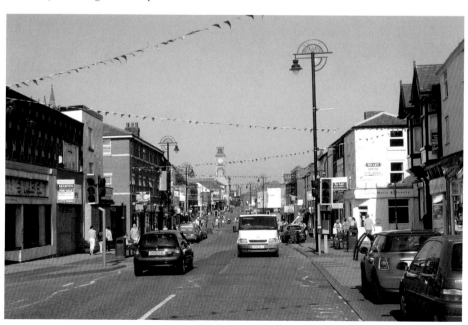

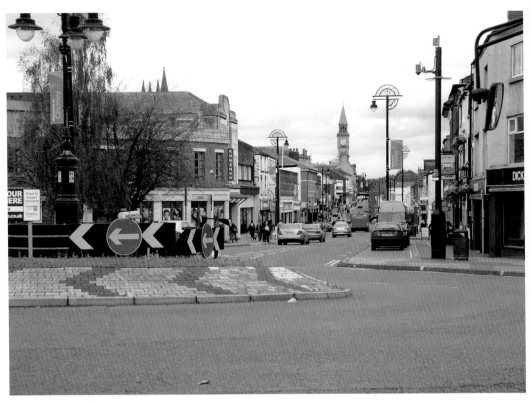

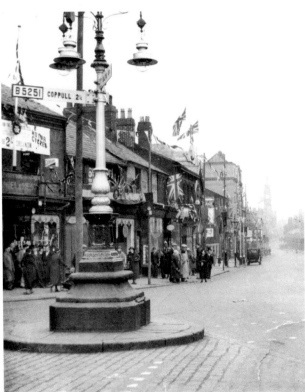

Big Lamp Corner

The junction of Market Street with Bolton Street and Pall Mall was a popular place for men to meet and observe people and vehicles in and out of town. It became known as 'Big Lamp' from the 1860s onwards, when a tall, decorated, cast-iron post with gas lamp atop was erected. Later, three gas lamps on brackets were fitted, as shown in this 1930s view looking north along Market Street. The flags are celebrating the 1935 Jubilee of King George V and Queen Mary. When the lamp was removed in the late 1940s there was a great outcry from Chorley folk who wanted it relocated nearby and electrified. Today, the former three-way junction is a crossroads with an island, on which is a new 'Big Lamp'. But this is nowhere near as impressive as the old decorated cast-iron post.

Traffic Problems

By the 1960s Chorley's former turnpike road had become a main 'A' trunk road, carrying traffic from Scotland to the south of England, and vice versa. Heavy lorries on overnight 'trunk routes', buses, express coaches etc. all passed through the town. At weekends and holiday periods, huge numbers of coaches from the midlands on day trips to Southport, Blackpool and the Lake District all came through the main street. If there were no policemen on point duty, it was nigh impossible to get across the street. Plus of course there were exhaust fumes to cope with. Long queues often formed, sometimes back as far as Yarrow Bridge, a mile to the south. The old photograph shows a queue of traffic in the 1960s. Today traffic is much less, and buildings at the end of cheapside have been demolished and/or rebuilt.

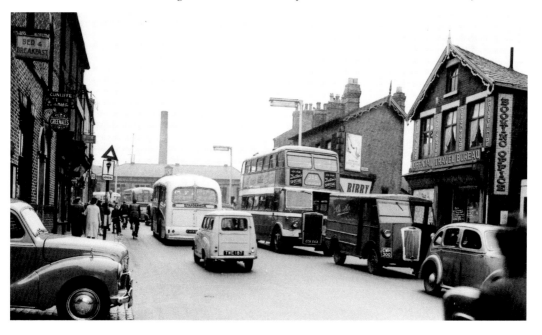

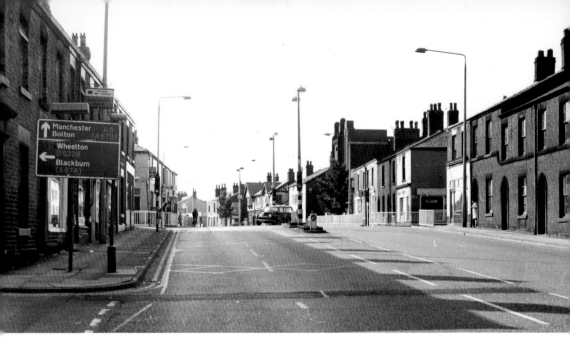

Bolton Street (Up Duke)

A view of the crossroads junction of Bolton Street/Bolton Road, with Lyons Lane to the left and Duke Street to the right. It was only fitted with traffic lights, on trial, in the late 1950s. In the early 1960s they were refitted permanently. This area was popular for men to 'watch traffic', hoping to see a bump, to give them something to talk about. The term 'up Duke', came about due to the popularity of the crossroads for this purpose before the traffic lights were installed – helped by the fact that there were five pubs close by to quench their thirst! To the right in the distance, past Duke Street, the Art Deco-style Plaza cinema building is visible. Built in the 1930s, the last film was shown in the 1970s. In November/December 2011, it was demolished. Today's view shows the changes due to the building of the town centre bypass and demolition.

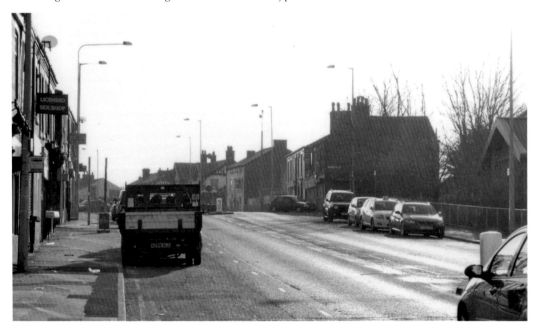

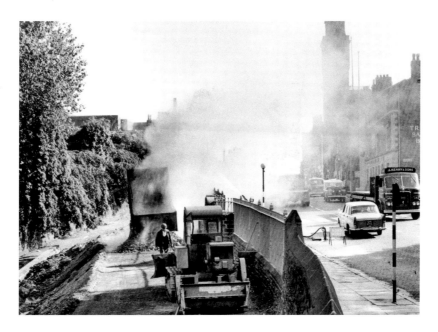

A Traffic Solution Scheme on Park Road

The volume of traffic passing through the town centre in the 1960s forced the local authority to do something about it. A town bypass had been mooted in the 1930s, but that had been forgotten, even though from time to time it had been raised at council meetings in the 1950s. The new proposal was to widen Park Road north of the Parish Church as far as the park gates. This entailed the filling in of the former Church Brow, and creating a footway only instead of a carriageway. This meant the loss of the historical Anne Pollard Drinking Fountain, and the old turnpike road down to Chorley Bottoms, as this part of Water Street was called. The old view shows work having started on the filling of Church Brow in 1964. Today the infill is a grassy slope, with steps close to the churchyard wall leading down into Hollinshead Street and Water Street.

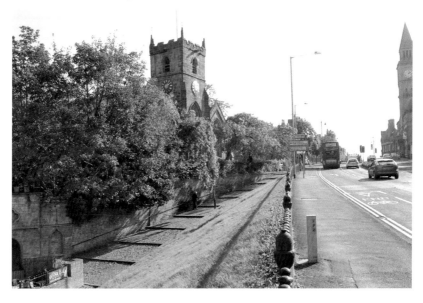

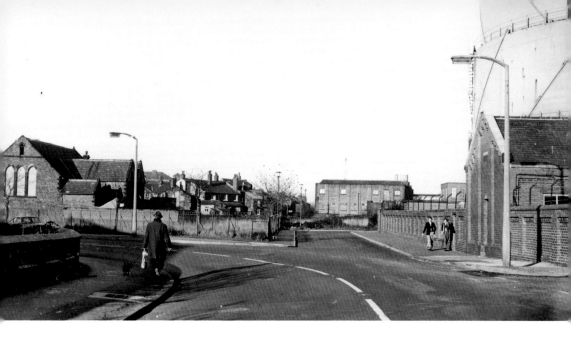

Old Roads for New

The opening of the town centre bypass in the 1990s reduced the flow of traffic through the town centre. At the same time a part of Market Street was pedestrianised. The new bypass road followed the line of Lyons Lane, Clifford Street Bengal and Water Street, to rejoin Preston Street, as it had done in the turnpike route time. The old view, dating from the 1960s, looks to the north along Bengal Street into Dacca Street. (I had a small allotment on the open land, while attending Hollinshead Street School). Beyond is the former Water Street works of Messrs Thomas Witter and Co. To the left, the former Parish Church Girls School is visible. The new bypass road has been widened, and the old 'three-cornered rec' is much smaller now. Today, the old Bengal Street is still visible, swinging to the left to rejoin Water Street.

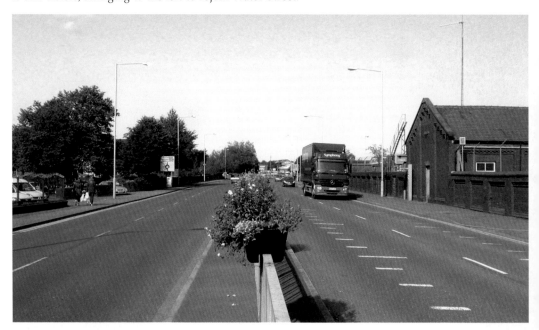

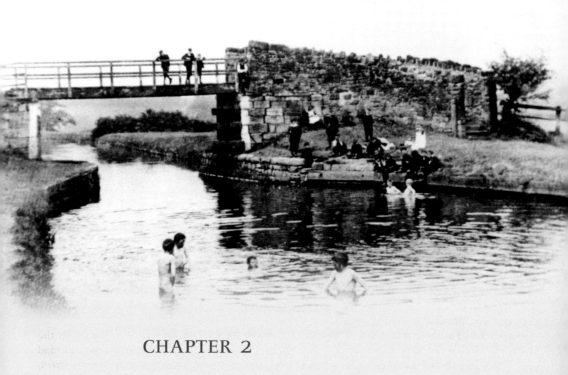

CHAPTER 2

People & Places

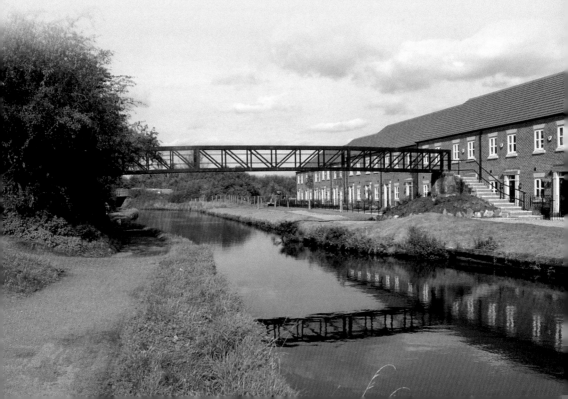

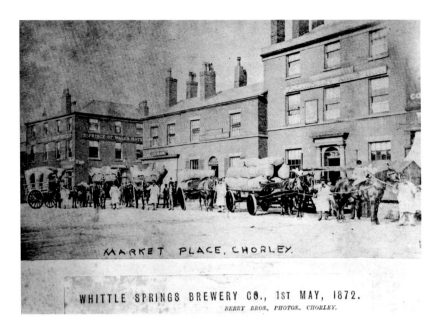

MARKET PLACE, CHORLEY.

WHITTLE SPRINGS BREWERY CO., 1ST MAY, 1872.

BERRY BROS., PHOTOS., CHORLEY.

Market Place Changes

This old view is embellished with 'Whittle Springs Brewery Co. 1st May 1872' and its position in Market Place. However, the three buildings were actually in New Market Street. The procession of carts is probably carrying cotton bales. The Prince of Wales pub, on the left, is a lucky survivor, for it was sited on the corner with Livesey Street. This corner was blocked off as the new shopping mall was built, and the Livesey street doors and windows into the pub were blocked up. Both Livesey Street and Hill Street were demolished in 2004. Between the streets, on the old view were a shop and a veterinary surgery, plus the Fazackerley Arms, all demolished 140 years after this nineteenth-century scene was captured. The shopping mall entrance is where the vets used to be.

The Cattle Market

Taken in around 1873, this old image demonstrates that the cattle market' or 'Flat Iron' that we know today really did sell cattle. The old picture was taken from a high point and to get the same perspective for 2012 I took the modern image from an upstairs window in the Sir Henry Tate pub, opened in 2006. Henry Tate was born in Chorley in 1819 and made a fortune in sugar refining. He became a sugar magnate and benefactor, founding the Tate Gallery in London. Today, the building on the left side, the Imperial, is still there.

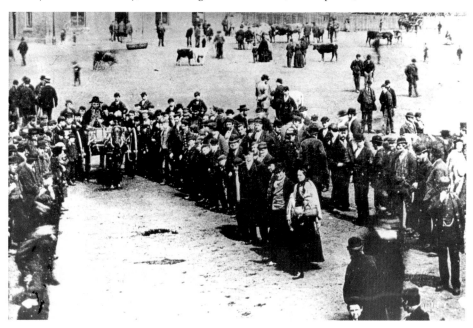

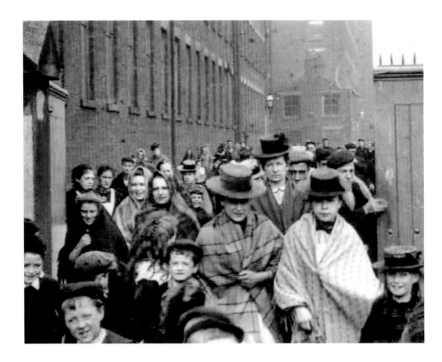

Cotton Mill Exodus

Chorley was a cotton spinning town, a trade with long roots in domestic spinning and weaving, long before steam powered mills were built in the late eighteenth century. There were more than twenty-five mills in Chorley, the last being erected in 1914 and demolished in 2011. Messrs Lawrence's was the last mill to spin and weave cotton yarns in the town before changing to man-made yarns but it too was demolished in 2011. The last shuttle used on the last Lancashire loom at the mill was given to the author. Our sepia view shows employees leaving North Street Mill in around 1900. In 1952 this mill had a flywheel burst which caused one death and much damage. Today there is a B&Q store on the mill site.

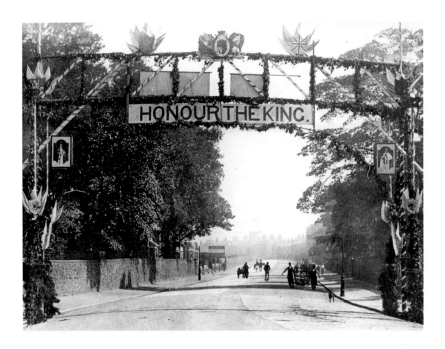

Honour the King

It seems to have been common for church groups and organisations in Chorley to build commemorative arches spanning the streets for many types of occasions, and particularly for royal events. Looking north up Park Road, to the left, just past the former Parish Church Institute, we see the wall surrounding the Astley Hall estate, later Astley Park. Notice how few houses there are. The banner 'Honour the King' celebrates the crowning of King Edward VII in August 1902. Today traffic is light on this former A6 trunk road and completely built up on the left-hand side of the road.

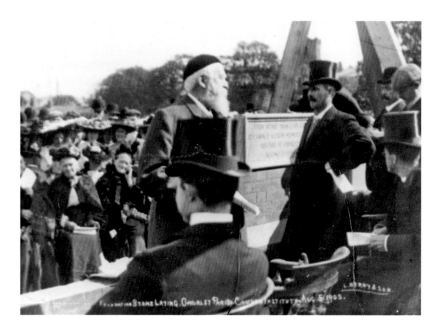

Foundation Stone Laid

On 5 August 1905, the foundation stone of St Laurence Parish Church Institute
was laid by Revd Canon Stowell, the bearded gentleman in the middle. The
attendees behind and to the left of him are 'inside' the future building, at second
floor level. The foundations were actually in Water Street where there was
later a bowling green. The Park Road entrance had two meeting rooms and a
smokers' room, with a function room above. In the 1970s the building fell into
disuse and was demolished. The foundation stone was recovered from a skip by
the author, who kept it for many years until a new Parish Room/Institute was
built, the stone then being donated back to the church and incorporated into
the wall of the new building, as shown in today's photograph.

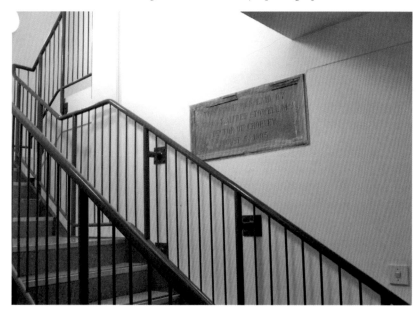

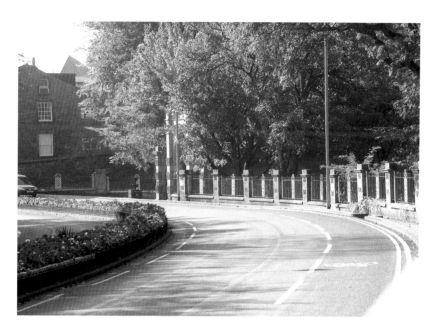

British Champion Walker

In this 1928 photograph the walker is Chorley postman Bob Bridges who, during the post-First World War years and the 1920s became the British Walking Champion. He is seen here competing in the Manchester to Blackpool Walking Race. The cyclists are local supporters. Those closest to Bob are race officials. Astley Park railings and estate wall are visible behind the cyclists on the right. On the left, is a building gable end, at the end of Queen's Road. Originally called Terrace Mount, it was the birthplace of Henry Tate, founder of the sugar empire. The building was the Trustee Savings Bank (having a symbol of Cornucopia on the front of the building), until this was relocated in Market Street. Today's photograph was taken in about the same position, while dodging traffic!

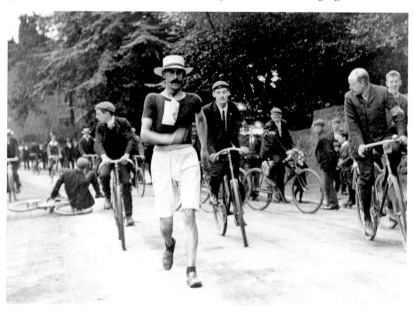

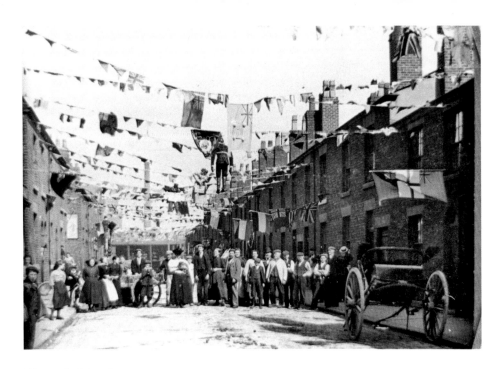

Victory Celebrations

Banners and bunting were often brought out to celebrate victories at home and abroad within the British Empire. This occasion is thought to be June 1902, when a Boer War victory was celebrated. The seven-month siege of the town of Mafeking by the Boers came to an end on 1 June. This became known as 'The Relief of Mafeking' and proved a huge boost to British morale. Why Livesey Street was selected to be photographed instead of a main street in the town is uncertain! Today, Chorley's shopping mall centre walkway is located to the left side of the sepia photograph, where the old footpath used to be.

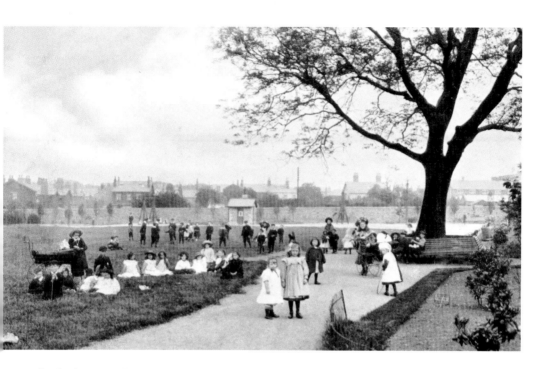

Chorley's Recreation Ground

The recreation ground in Devonshire Road was officially opened by King George V and Queen Mary in 1913. Following that visit, it became known as Coronation Recreation Ground. In this old view, we are looking to the north, from approximately where the central footpath runs from Ashfield Road to Devonshire Road. The houses in the distance are the backs of the big Victorian and Edwardian houses on St Thomas's Road, now mostly used as offices. The wall running left to right across the centre is that now behind houses in Collison Avenue. The children are thought to be from St Mary's School on Devonshire Road. The view today shows new housing, plus tennis courts and bowling greens have been added.

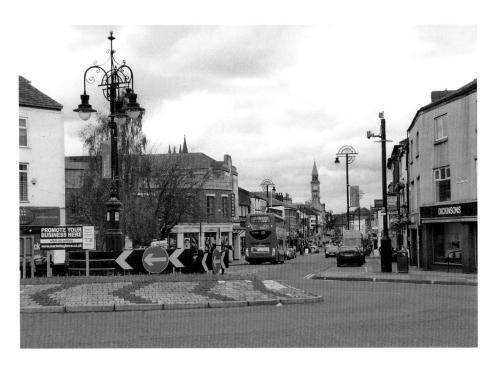

Walking Day, by the 'Big Lamp'

In the sepia view we see a church procession or Walk of Witness, usually just called Walking Day, passing into Pall Mall to the left. Here, at the very edge of the photograph is the circular stone base of the old 'Big Lamp'. Although the photograph is undated, it is likely to have been before 1911, as this was the year that the Theatre Royal was built in Market Street and it is not yet visible in this view. Also the Market Street chapel at the end of Cheapside is still in place. Market Street is to the centre and Bolton Street to the right. Today's view of this location illustrates how, through time, the buildings have changed. The same road is now a busy crossroads, with a new 'Big Lamp' on the island.

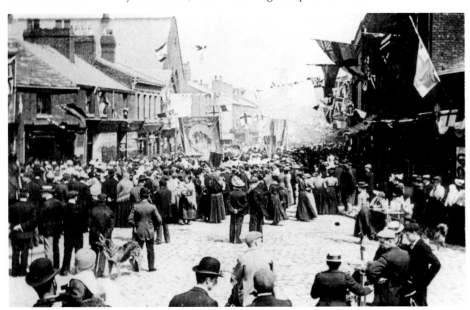

St Thomas's Square and Steam Wagon

In this old photograph, taken in St Thomas's Square, we look at the Victorian police station, demolished in 1963/64. The steam wagon is one belonging to Messrs Sumner's corn mill, which was off to the left of the photograph. Reversing into the yard of the mill was always a major problem, for the vehicles could not turn around when they were in it. The yard was enclosed by buildings. It was easy running forward out of the yard gateway, but traffic always had to be stopped when this took place. Here, in the early years of the 1900s, we see a Leyland steam lorry waiting to reverse into the yard with a full load of grain for milling. Today the corm mill and police station have been demolished and replaced an office block and a new police station.

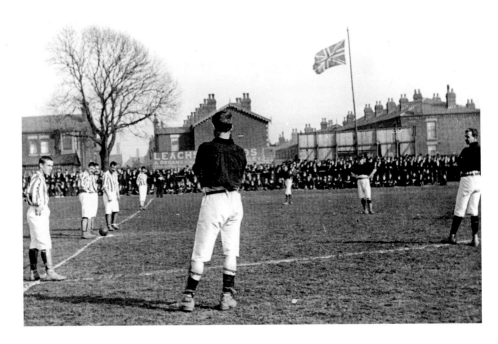

Chorley Football Team on Dole Field

When Coronation Rec' was opened, there was separate mention of a 'field'. This was part of the old 'Dole Fields' and was the area that Devonshire Road ran through. A portion of this old field system was incorporated within the recreation ground boundary fence. Here we see a football match about to start on that old part of Dole Fields, at the centre circle, with the referee's back to the camera (how about the suspenders for his stockings!). The Chorley Team, in its black and white 'magpie' strip, is to the left. The distant buildings at the end of Gillibrand Street have changed little over time. The wooden hoardings are where today's gates are, at the Devonshire Road entrance.

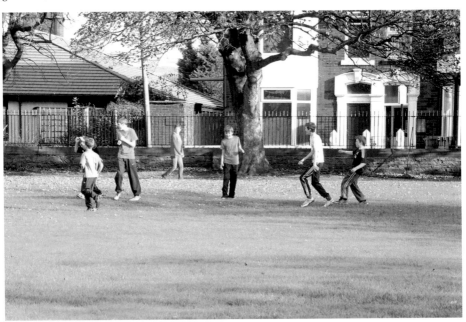

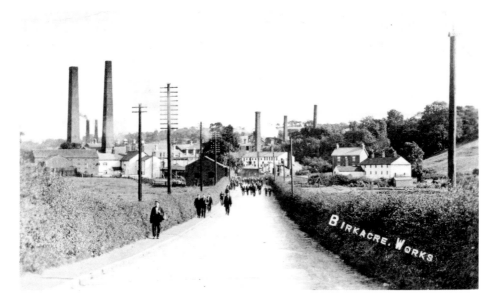

Birkacre Bleachworks

Located 2 miles south-west of the town, Birkacre is famous for its industrial history. Manorial water corn mills were here from the sixteenth century. In 1797, a mill was built by the local landowner and leased to Richard Arkwright, inventor of many cotton manufacturing processes. In the mill he installed his water-driven spinning frames, and the mill worked successfully for two years before it was besieged by rioters in 1799 and burned down. It was the first powered cotton mill locally. Later the site became a bleach and dyeworks. The 1920s picture shows the extent of the works, all demolished from the 1930s. The 1980s saw restoration of the area. I was involved, giving historical information and advice, and producing pamphlet guides. Today's view looks towards the works and country park site, with tree coverage hiding the car park and visitor centre.

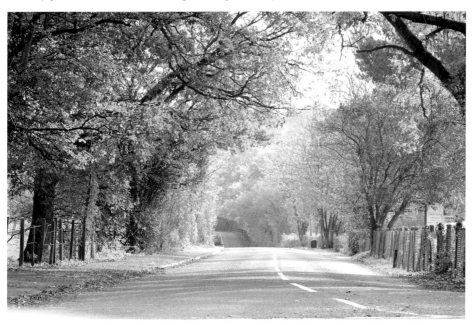

33

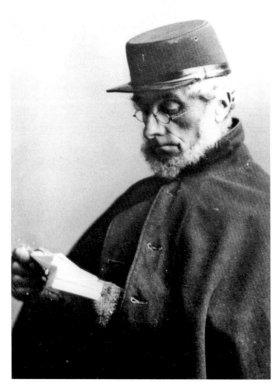

Postmen Through Time!

Chorley's postal service began in the early 1800s when mail coaches dropped the mail at Terrace Mount office. During this early period up to 1845 only one postman, named Mr Jolly, served the town. His son James joined him this year becoming number two. The postal office moved about quite a lot over the nineteenth century, twice into Market Street, once into Market Place, until finally into a purpose-built premises in High Street in 1926. Today's postal service has moved from the High Street building to a larger premises off Friday Street. During the early years of the postal service it would seem that the dress code was a more rigid than it is today; the present day Chorley postman's uniform, with shorts and floppy hat, is quite relaxed.

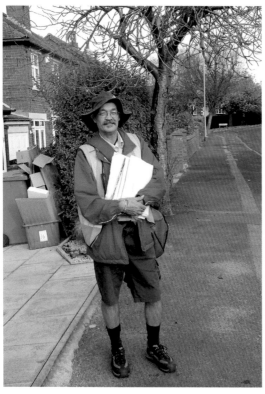

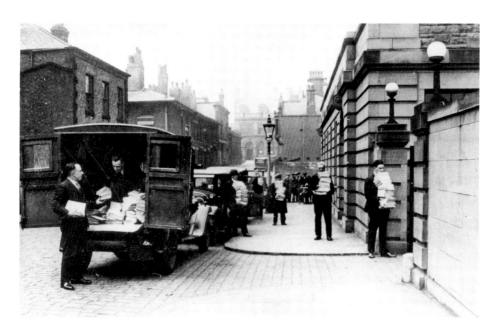

Pamphlets for Fundraising

The date of our sepia view is 1933; the location is the building I spoke of in the previous page caption, the 1926 post office in High Street. This view was taken looking west up the street. In the distance the older shops and offices are evident, before demolition in 1937. The vans outside the building are carrying pamphlets, being taken into the post office for delivery with the mail. The pamphlets were to help raise money for the new Chorley and District Hospital, under construction. Later a first floor was added to this originally single-storey building and served as an automatic telephone exchange. The building is no longer the main post office. Note how the buildings higher up the street have been rebuilt.

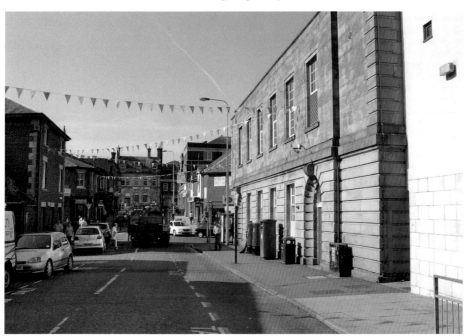

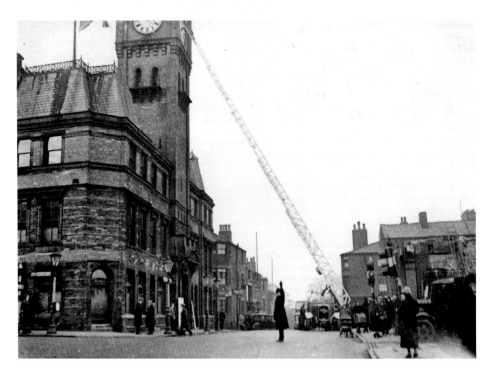

High-Rise Repairs!

The old photograph location is the town hall. The local fire brigade has been called in to help with a clock hand problem. The rescue ladder has been raised to its full height of four extensions to get to the clock face, with one intrepid fireman at the top. (I wonder if he was a volunteer?) Apparently, the problem was that the hands of that clock had become stuck, and could not be moved from inside the tower. The date must be 1937, for to the right the old Royal Oak is being demolished for road widening. Today there are three lanes in front of the town hall and all the old property to the right has gone.

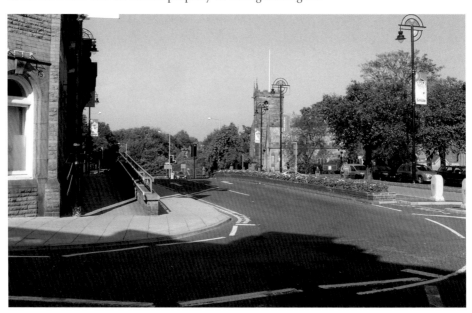

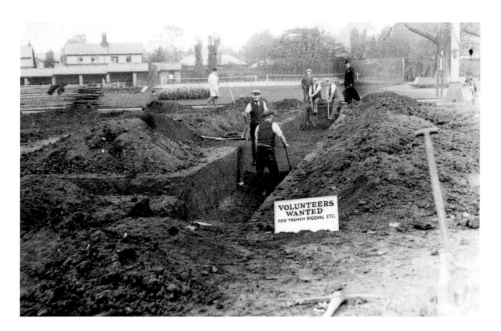

Dig an Air Raid Shelter!

We return to Coronation Recreation Ground in 1938. As they say, 'the storm clouds were gathering over Europe' and it was time to get ready for the possibility of war. Already a large Royal Ordnance Factory was being built outside Chorley. Community air raid shelters had to be constructed. Here on the 'rec', close to Devonshire Road, a deep shelter was being dug, with a notice asking for volunteers to help. I recall this shelter as a boy. A deep ramp led down to it, and its multi-rows of seating corridors were great to explore with torches or candles in jars. Today one cannot imagine a building still lies deep below the ground at this location. When it was closed, the entrance was blocked up, and the ramp filled in. But it's still there! Perhaps it will be re-excavated in the future.

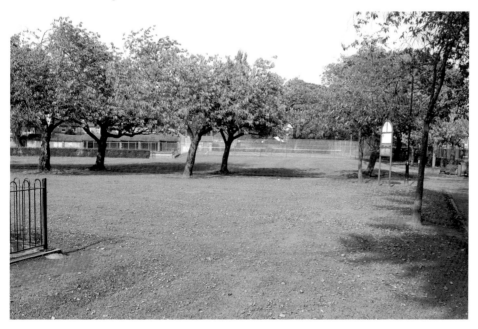

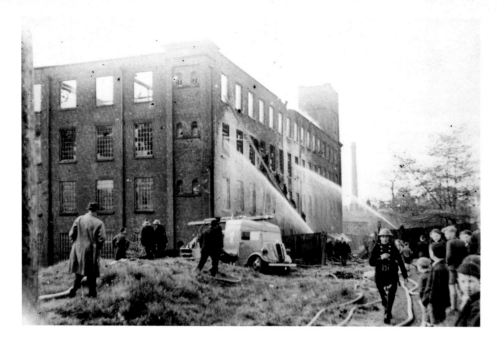

Cotton Mill Fire

Although a large number of local people believe that this fire in 1944 was due to German action, this was not the case. The mill is Cross Hall Mill in Crosse Hall Street off Cowling Brow, which was a part of the Gillett family empire. Together with the adjacent Redan Mill, it produced spun cotton yarns. The three-storey brick-built mill was almost completely gutted with the fire, and most of it (from nearest to the camera end) was demolished. The part of the mill building saved, including the water tower, was restored and is still in use today, along with the former engine house. My present day view illustrates that part of the mill in Crosse Hall Lane, still in use in 2012.

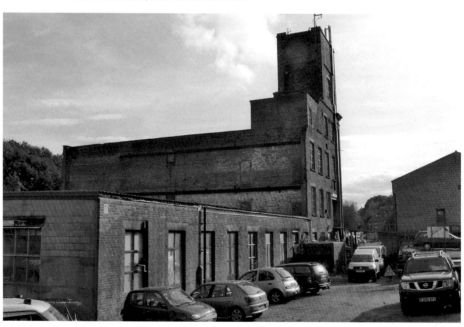

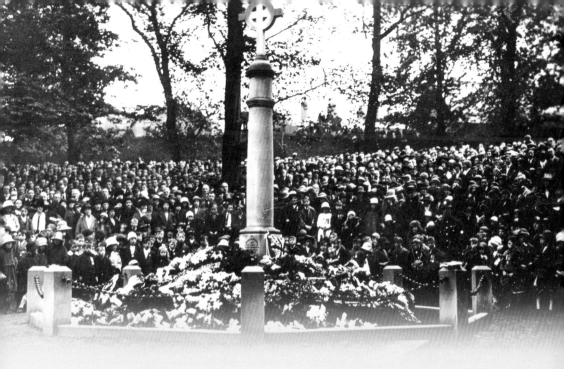

CHAPTER 3

Streets & Buildings

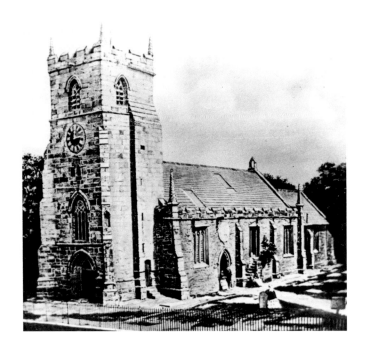

The Parish Church

Chorley's oldest surviving building is its parish church of St Laurence. Its origins were in the thirteenth century, when there is mention of a 'chapel'. Its oldest surviving portion today is its short pinnacled fifteenth-century tower, added to the west end of the early stone church in the as shown in this photograph from around 1859. The central nave had chancels added in 1860–62. Many of the Standish family are associated with the church, including Myles Standish who sailed on the *Mayflower* with the Pilgrim Fathers. It is the author's church, where he served as chorister and learned the art of bellringing. Today, the church is as vital to Chorley as it ever was, the sturdy squat tower seemingly 'standing guard' over the town. Over the past decade or so the pew arrangement has been altered to allow a wider range of use. A new parish refectory was added also (see page 26).

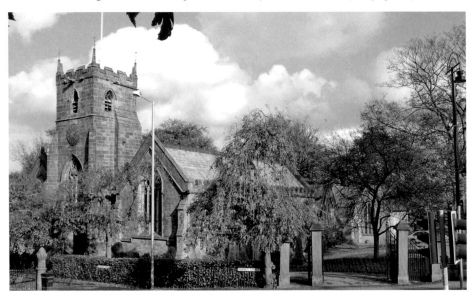

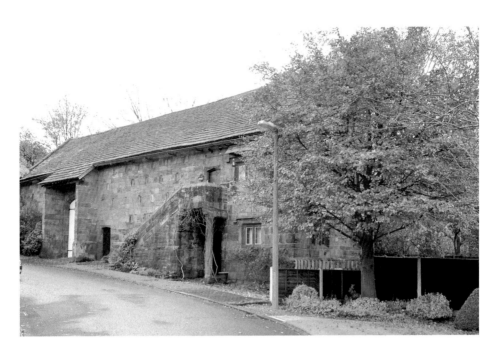

Gillibrand Hall

The original Gillibrand Hall was a medieval timber-framed building enclosed by a moat. The seventeenth century saw the establishment of a hall farm and much rebuilding, including a substantial stone barn bearing the dated 1668 and the crossed swords crest of the Gillibrand family. The building also contains many stones with masons' marks of different types. By the late 1960s the home farm was demolished and the barn was left to deteriorate, but in the early 1970s the Gillibrand Arts Centre was set up there and the barn's future became secure. Sadly, however, this group did not last long and the barn was eventually purchased for conversion to a private dwelling, as it is today. Its exterior is little changed from its original build.

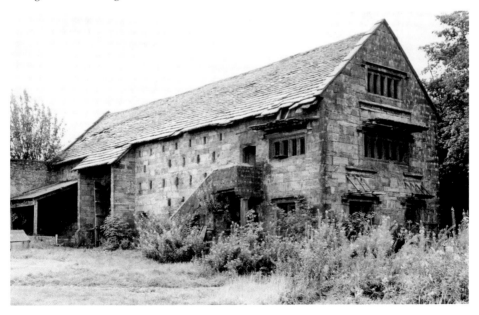

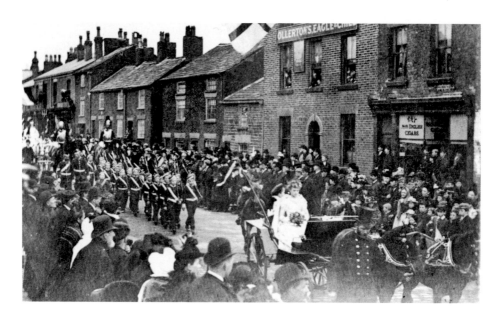

Rose Queen Procession

Processions and parades of differing sizes have featured in Chorley through time, for many groups and organisations, with parades for Rose Queen, Cotton Queen and Railway Queen, and for the 'Kings' of Cowling and Botany districts. On this locally produced postcard we are told that this procession, approaching the 'Big Lamp' in Pall Mall in June 1891, was for a Rose Queen, but we are not told who she was or from where. The parade passes the Eagle & Child pub, which despite its successive renovations has now been empty for quite some time and its future is in doubt. Note the old properties to the left of the photograph, all long-demolished to make a pub car park, which itself is now almost covered by small trees and shrubs, surrounded by fencing! Like many other pubs, the Eagle will most likely not re-open as a pub.

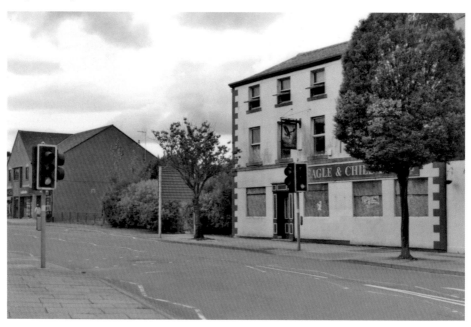

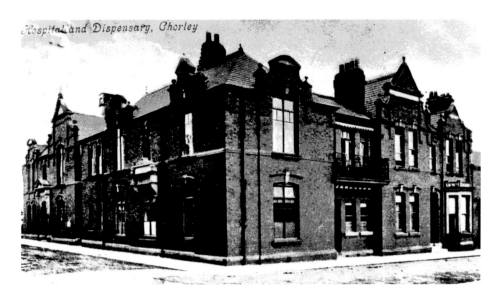

Hospital and Dispensary, Chorley

Rawcliffe Hospital

By the 1880s, Chorley still had no hospital. In 1890 a new benefactor, Mr Henry Rawcliffe provided the funding for Chorley's first hospital. This was built with gardens and a driveway entrance from Lennon Street. Before long, an extension was built to Gillibrand Street, where another entrance was made. When Chroley and District Hospital opened in 1934, rawcliffe Hospital closed, to become the offices for Chroley Rural District Council and later the Planning Office for Chorley Borough Council. In 2009 Chorley Community Housing moved in and they may vacate in March 2012. The future of the building is uncertain, but as part of the town's social history, it would perhaps be ideal for a Chorley Arts and Heritage Centre. The building has changed little through time, except that the chimmneys and stone decoration have been removed.

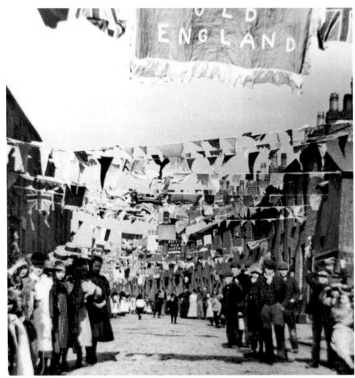

Queen Victoria's Diamond Jubilee

Another occasion for bunting and flags occurred in 1897: Queen Victoria's Diamond Jubilee. Here we see Chorley's Anderton Street gaily decorated, as were the town's main streets and buildings. In addition to the many decorations it was one of those occasions when men from a local church or other organisation would erect wooden archways across the streets of the town. The street of terraced houses has changed little in more than a century, except for a few trees.

Watching Traffic

Put a group of men, a road junction and a lamppost together and you have a meeting place for watching traffic, even though it is in the middle of the road and the lamppost has yet to actually acquire its gas lamp. This 1870s view of a popular Chorley location shows the turnpike route running from Market Street to Bolton Street on the right. From 1868 the area at the junction of today's Pall Mall became known as the 'Big Lamp', as it still is today. The properties beyond the men were demolished when George Street was extended to form a crossroads a few years ago, and the traffic flow at this area is very high. Obtaining the modern photographs here was extremely dangerous!

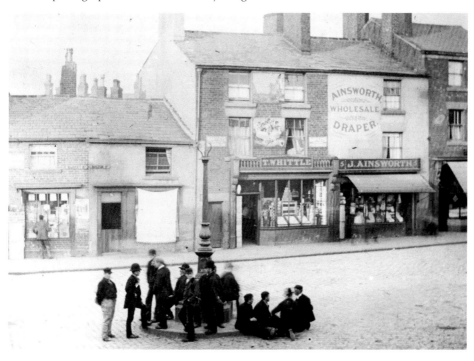

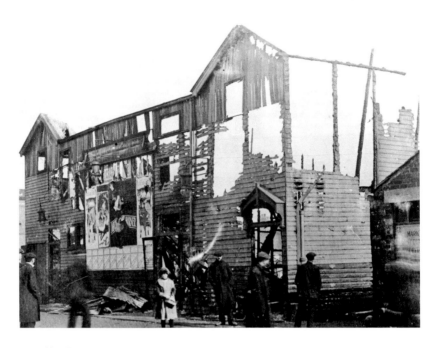

Santé's Theatre Fire

Mr Testo Santé was a theatrical entrepreneur and a showman who settled in Chorley in the late nineteenth century, living in Hollinshead Street. His first major venture in the town was to create a skating facility and a variety venue, which later became the Pavilion cinema. In the mid-1890s he built a wooden theatre on the Flat Iron market which became one of Chorley's main attractions, showing plays and variety acts. Sadly, the large building was destroyed by fire in 1914. Just visible on the extreme left side of the burnt theatre is the frontage of the Imperial Hotel. Today the 'Flat Iron' market space is used mostly as a car park.

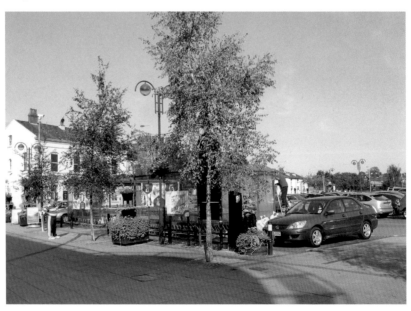

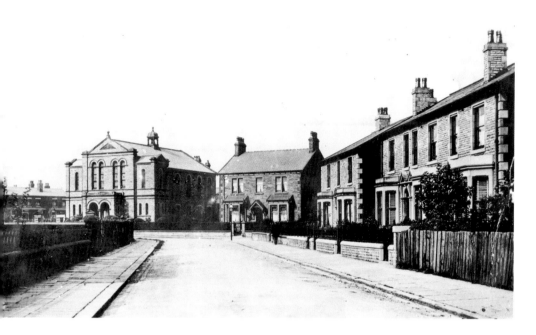

Trinity Church

This view from a postcard dated 23 January 1909 shows stone houses to the east side of Rawcliffe Road with Trinity Church and Manse in the distance. An earlier undated postcard shows the laying of the foundation stone for the church, with hundreds of spectators watching within an area of open space. The Gillibrand Hall entrance gates are visible behind them (now the gates to Astley Park). The postcard shows no development to the west of the road, but today this is built upon. Trinity School, with its rusticated stonework, just past the church, would not be built until 1933.

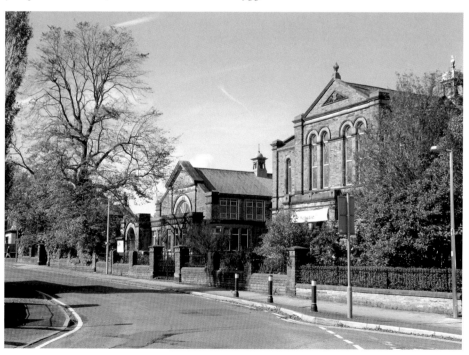

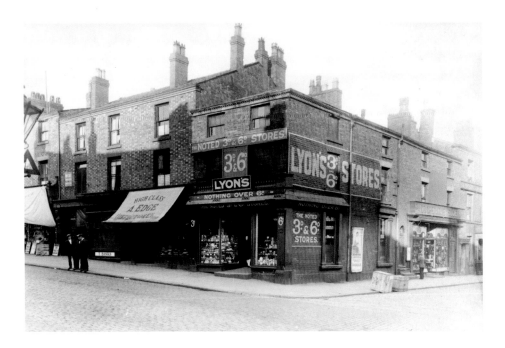

Chorley's 3d and 6d Store

Chorley's first town-centre Co-operative Society shop was in Fazackerley Street shopping area. A customer is browsing in its window, next to the Commercial pub. At the corner of Fazackerley Street and Market Street was the popular Lyon's 3d and 6d Stores, its motto being 'Nothing over sixpence', and frequently quoted in the town. It was eventually purchased by Chorley Co-operative Society and demolished, and a new, much larger general store incorporating the original Co-op shop was built on the site. Also visible is Mr Tom Banks' butcher's shop. I worked for him as local delivery boy. As lads we often carried his bags home to Queens Road for him, to be tipped with a few coppers! The extended size of the Co-op store can still be identified; it is used today as a property sales office.

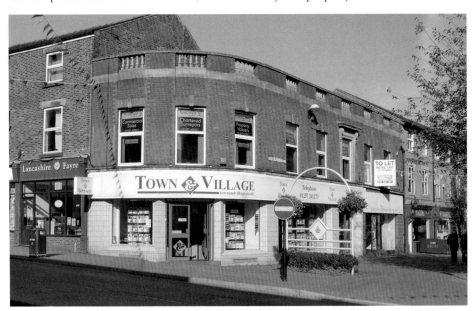

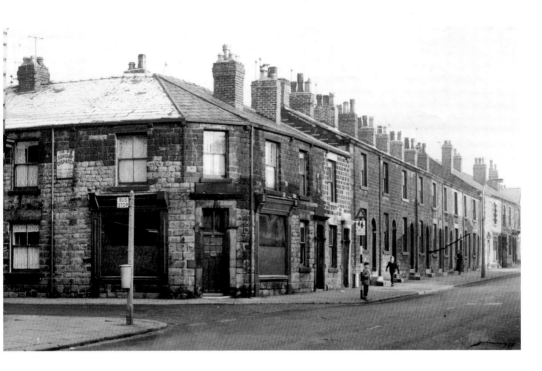

Chorley's First Co-op Venture

Chorley's first Co-operative scheme was introduced as an industrial location at Birkacre Bleachworks in 1831. The first co-operative movement shop was set up in Chorley about 1871 at the corner of Little Steeley Lane and Lyons Lane. It was from this small corner shop that Chorley's co-operative movement grew, with main offices at Lyons Lane and its warehousing and distribution depot (and dance hall) in Little Steeley Lane. The old view shows the original shop with corner doorway. Adjoining the shop in Lyons Lane were cellared cottages, probably weaving premises, now replaced by modern housing.

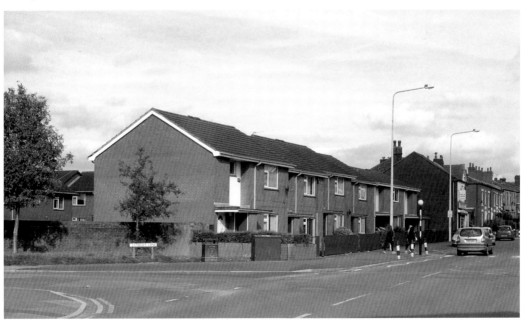

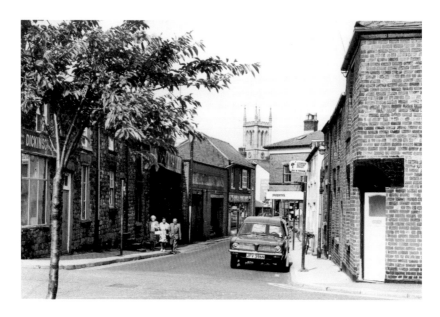

Cheapside

In this mid-1970s view we look from Fleet Street towards Market Street. Fleet Street and Cheapside both had many cellar dwellings, which were used for spinning and weaving, but in this photograph only two remain complete, between Messrs. Dickinsons' piano workshop and Cliff Owen's garage. A building extension of Runshaw College has replaced them, based in the former Norweb Electricity showrooms. To the right hand side, the cottages that shared a communal back yard are gone, but the white building still remains. Incidentally, the cottage with the corner door used to be a public house. Today there is open space where the cottages were. In place of the corner door, base stonework and a short obelisk stand. It was made by me and my colleague, historian Stuart Whalley, to commemorate the lost 'Weeping Cross' that used to be nearby.

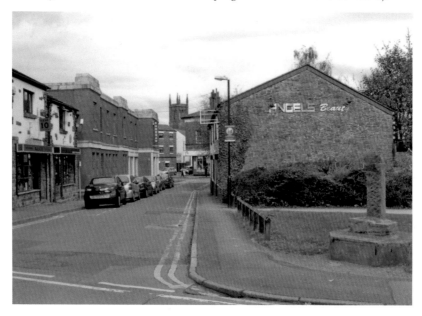

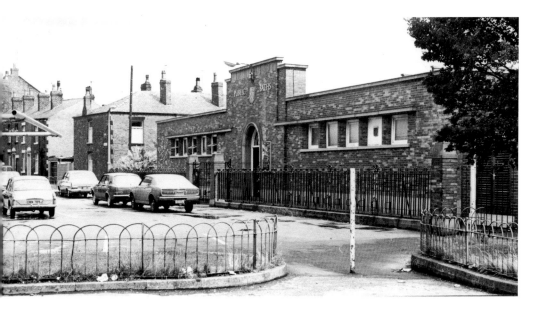

The Public Baths

Chorley's first public baths was built on the Flat Iron, Clifford Street side, in the 1930s and officially opened in 1935. Its plunge pool had seats around it and was often used for competitions, with large audiences. In addition to the plunge pool there were slipper baths for men and women. The 1960s saw the addition of a children's pool to the south end and in the 1970s a squash court was built on the west front. In the 1990s, new baths in Water Street were built and the old ones demolished, making another much-needed car park. In the distance one can see Byron Street with Hollinshead Street School just visible. Today, the site is part of the 'Flat Iron' car park, as the 2012 overview shows.

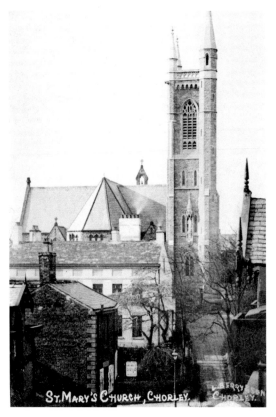

St. Mary's Church, Chorley.

St Mary's Tower

The first church building was erected on the Mount Pleasant site in 1853 and the present church dates from 1872. Designed by John Hansom of Hansom cabs fame, the church was known locally as a 'three-decker', originally combining church and school under one roof. The original and main approach is from Market Street, through the Canon Crank commemorative archway opposite Chapel Street. The eight-peal bell tower was erected in 1894 and stands 130 feet tall. Originally the bells were hung too high and caused the tower to move too much, so they were lowered by several feet. Delivering the bells also created a problem – the cart driver whipped the horses down Chapel Street and they shot up the hill to Mount Pleasant! The bells are a delight to ring here and very accessible.

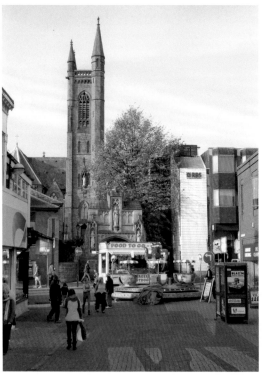

Haydock's Saw Mill

Haydock's was a family firm, established in purpose-built premises on the corner of Hill Street and Clifford Street. It had a large brick tower with the name 'P.H. Haydock & Co, 1910' in white brick. Below it were coal-fired Lancashire boilers for heating the premises and for applications to some timbers. The saw mill cut complete logs into planks and beams which were then allowed to cure for a period in large sheds adjacent to a railway goods yard, from which the timber was then dispatched. Following the saw mill's closure, the company relocated to Wigan Lane, south of Chorley. The work's chimney and tower were demolished and the main works building was converted into Chorley's first Morrison's supermarket until the mid-1990s, when the shopping mall was built and all the buildings in Hill Street and adjoining Livesey Street were demolished. Just visible on the mill tower view is St George's Church, which I have used as opposed to the wall of a shopping mall service area.

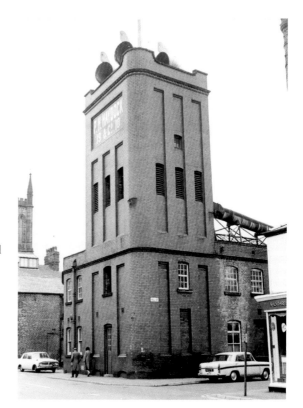

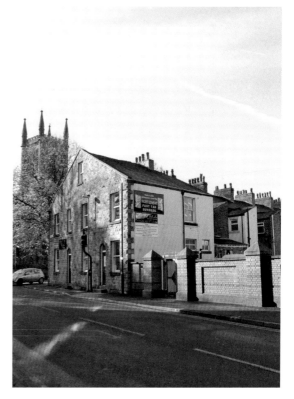

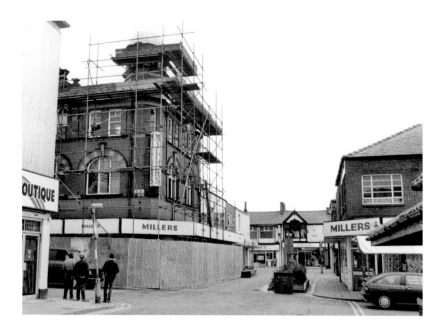

New Market Street

Not many years ago, on Saturday market days many people had a fish and chips lunch in Hill Street, seen here on the left with its junction with New Market Street. If decorating the house, one might have visited Messrs Miller's emporium to purchase paints, curtains and wallpapers etc. from within the three floors of the shop. The building works in operation were due to problems with the terracotta dome and the parapets. The building was subsequently vacated and a new emporium built across the road in around 1970, which continued the same business. The building of the shopping mall necessitated the demolition of the former domed premises which was on the corner of Hill Street. Today's view, looking in the same direction, shows how the former building and those adjacent have been rebuilt, still with a tower, where the dome used to be.

The Old Police Station

Chorley's Victorian police station had its front entrance on St Thomas's Road, the first floor containing the courtroom with separate official and public access. In the old photograph, the official court entrance is on St Thomas's Square. To the right, past the police station itself, are police offices plus the house of the Police Superintendent for Chorley. To the rear of the station was a large yard bounded on two sides with garages for police cars, the local Office for Weights and Measures and three houses for police officers fronting onto Farrington Street. As a child I lived with my parents next to the police houses, my mother working at the police station itself. In 1963/64 the whole block bounded by St Thomas's Road, Crown Street and Farrington Street was demolished, with a new police station and separate courthouse opening on the site in 1965.

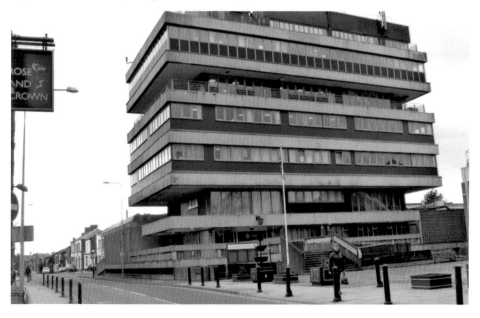

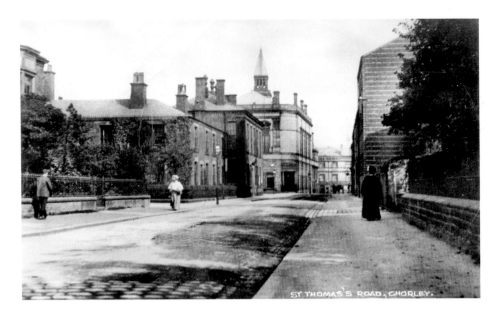

ST THOMAS'S ROAD, CHORLEY.

St Thomas's Road

From the west looking along St Thomas's Road towards a distant Royal Oak Hotel (demolished in 1937/38) we see the police station from the opposite direction. In the centre distance is the Town Hall and St Thomas's Square. Behind the lady with the light cape to the left of centre are the Police Superintendent's home and offices associated with Chorley police station, with Crown Street to the side. Just visible to the extreme left is a large private house fronted by railings. Today this building is used as office premises. To the right of the picture, the end of Devonshire Road can be seen, the low wall and railings surrounding the garden of Messrs. Sumner's large house. In today's view the lines of the modern police station dominate the scene, its architecture contrasting with the Victorian town hall.

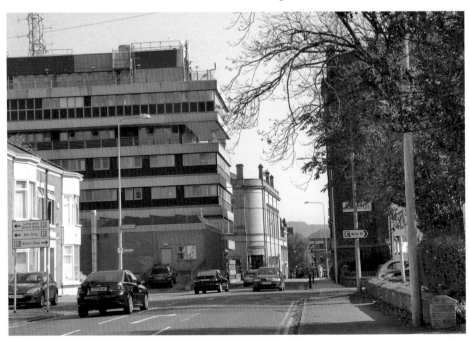

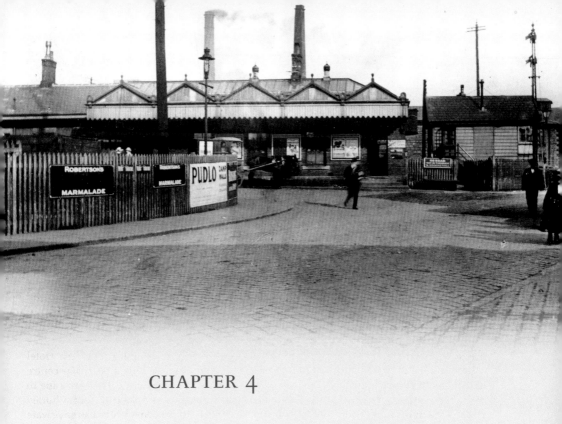

CHAPTER 4

Views Around Town

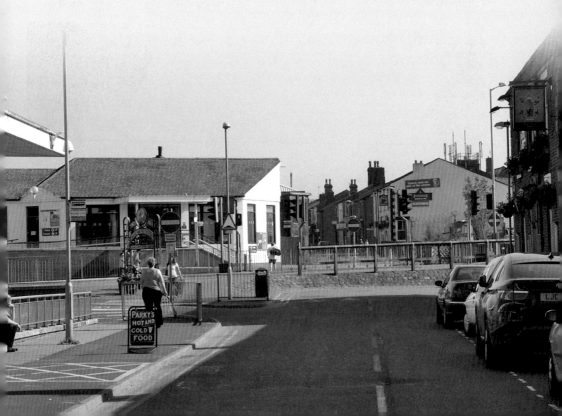

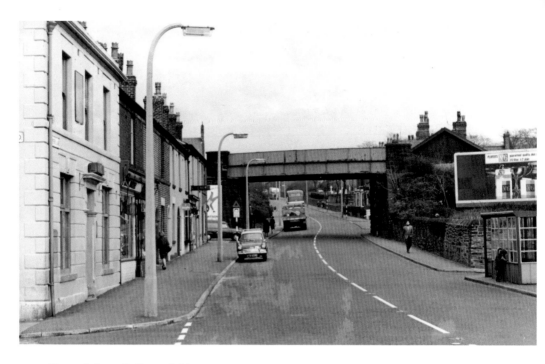

Harper's Lane Railway Bridge

Harper's Lane had the Chorley to Blackburn railway crossing over it from the 1860s to 1967, when the tracks were lifted and the line closed. On the sides of the bridge parapet there used to be an advertisement for a well known brand of headache powders called 'Cephos'. The bridge was given this nickname despite the advert being replaced over time. The coming of the M61 motorway led to the demolition of the eight-arch viaduct at Botany, and the former track bed from Botany. The embankments each side of the bridge have been mostly replaced by footpaths, walks and some housing, and planted with trees.

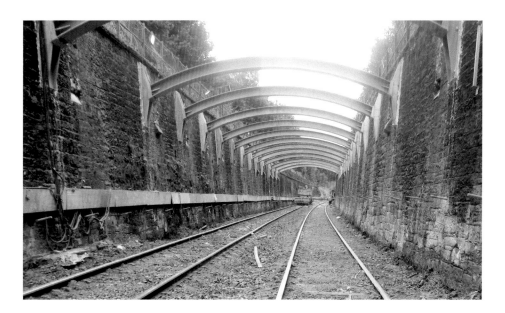

Hartwood Railway Arches

The Bolton to Preston via Chorley railway was built in the early 1840s by the engineer Alexander Adie. Approaching Chorley from the south, a large viaduct was necessary to cross the valley of Black Brook. Construction of the line was also underway north of Chorley at Hartwood, where a 300-yard tunnel was to be built. Due to the wet, sandy conditions when boring the tunnel, it was decided to make an open cutting with a 100-yard tunnel in the centre only. At the west end a very steep cutting had to be built. To ensure no slippage of the embankment occurred, sixteen stone arches were built above the tracks in 1842. These unique arches were removed in 2009 and steel arch replacements were fitted, as shown above. The stone arches were due to be replaced within two years, but this is still pending in January 2012.

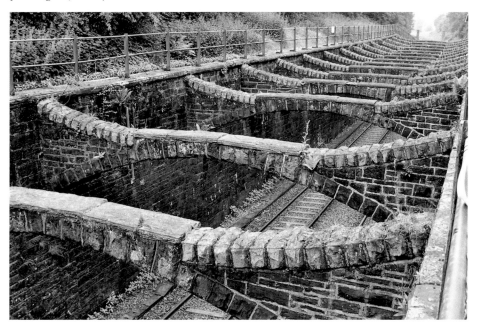

Halliwell Lane to Botany

Our old view was taken in the 1950s, looking south along the former Halliwell Lane towards Botany. Widows' Canal Mill and the eight-arched railway viaduct carrying the Chorley to Blackburn railway are visible beyond the mill. Halliwell Lane was a favourite place to walk through until the 1960s when it became known that the M61 motorway was to be built alongside the mill. This would also mean demolition of the railway viaduct, whose rails had been lifted some years before. Demolition of the arches took place in 1968 followed by construction of the M61 running southward from this viewpoint, passing close to the mill, towards Manchester. Today's photograph was taken from Hartwood roundabout over-bridge in approximately the same location as the old photograph.

Gilbraith's (Widows' Canal Mill)

Widows' Canal Mill was an 1855 multi-storey spinning cotton mill, built adjacent to the Leeds to Liverpool canal, with canal boats bringing coal and raw cotton to the mill. It closed in the late 1950s and in 1968 was converted into a huge warehouse that supplied components for Leyland trucks. This company, Gilbraith Commercials Ltd, occupied the mill until it was sold in 1994 and developed as a themed visitor attraction, opening in 1995. The famous Botany Bay complex is advertised on TV and is a popular multi-floored venue for browsing, shopping and eventually relaxing in the comfortable armchairs in its coffee lounge.

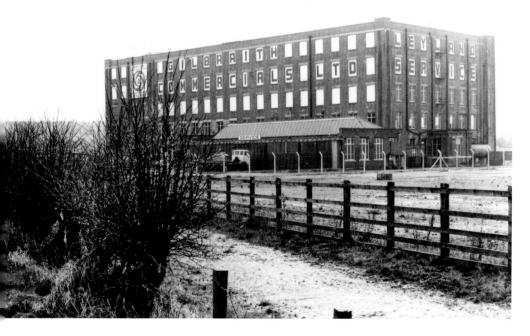

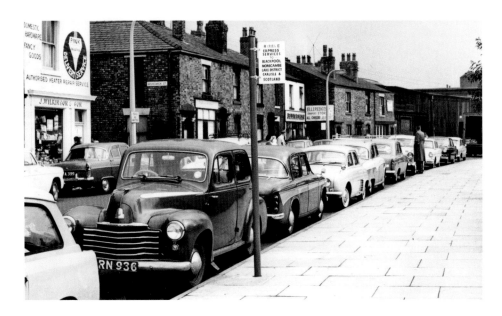

Traffic Parked in Clifford Street

Chorley's 1930s bus station was rebuilt in the 1960s, becoming a 'front end in' as opposed to a 'run through' station. During the time of demolition and rebuilding, the entire area became a building site for several months. However, Chorley's multi-route buses were still necessary, even without a fixed terminus! The solution was one which not only caused passengers confusion but which created traffic problems too. The reason was that most of the bus stop destination points were temporarily sited on the pavements of Union Street and Clifford Street, as in this August 1969 view along Clifford Street. Cars are parked nose to tail on both sides of the road, obliterating the 'express' bus stop and causing the buses to block the road when picking up passengers. Brunswick Street is to the left, but now forms part of a car park, to the left in today's photograph.

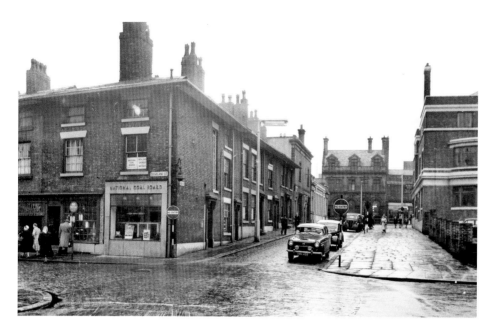

High Street

Taken on a dull and rainy day in 1958, our photograph looks up High Street to buildings on Market Street in the distance. The wide footpath to the right hand side of High Street, is now halved in width, to facilitate traffic flow and car parking. On the right hand side, the corner building is the Royal Oak Hotel, erected in 1937/38, which fronts onto Market Street. It stands further back from Market Street than its original namesake. Note that the hotel has a car park behind it. Most of this area is now built upon, with shops fronting onto High Street as can be seen in the modern photograph. People recalling this area in the 1950s will remember the wonderful antique shop at the left side of the picture on Cleveland Street, occupied at the time by Messrs Hogarth.

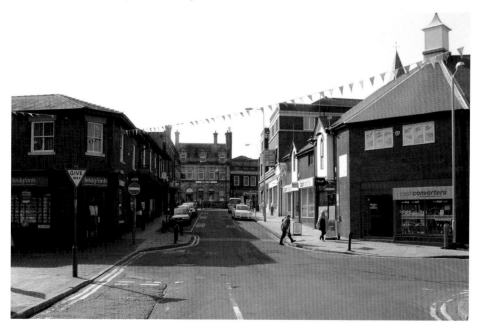

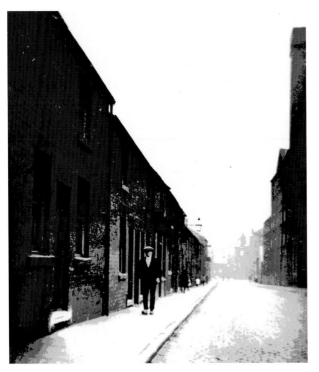

Standish Street

The Standish Street of today no longer has houses on the left-hand side as depicted on this old photograph. Where the houses stood there is now a Ford cars salesroom and maintenance workshops. Still on the left side, out of camera view, was the large stone Lightoller cotton mill, owned by the family, who lived at Yarrow House (where Herbert Lightoller, of *Titanic* fame was born). Timothy Lightoller was one of the early cotton masters in Chorley at the beginning of the twentieth century. That mill is now demolished. On the right-hand side of the picture stands another mill which has always been regarded as Lightoller's second mill. The building remains, but its tower is covered by modern telephone communications aerials. A pub on Standish Street called the Hare & Hounds was nicknamed the 'War Office' due to the many fights that took place there.

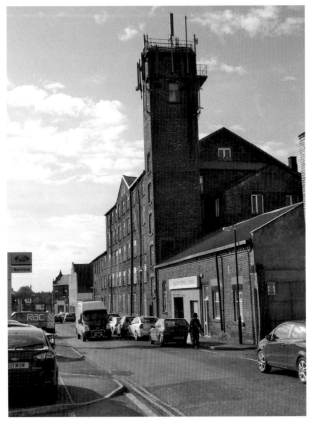

Hollinshead Street United Reform Church

Founded in 1783 and erected in 1792, the Independent church became Congregational in 1805 and is now a United Reform church. Adjacent to the church is the school, originally a primary school, now a nursery school. The Hollinshead name stems from a family who had had their family seat at Hollinshead Hall in Tockholes; a smaller family house was also built close to the site of Hollinshead Street church. John Hollinshead was a benefactor for the building of Chorley's first Town Hall in 1802. Our old photograph shows the north front of the church without its gable end wall, due to structural problems which were corrected and the front rebuilt, as shown in the 2011 photograph.

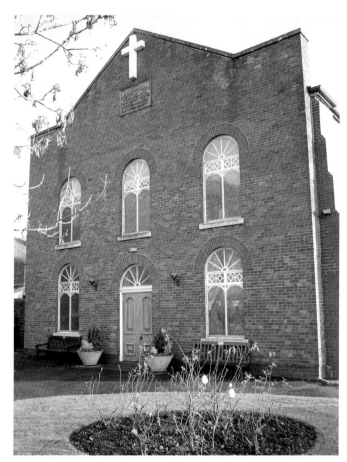

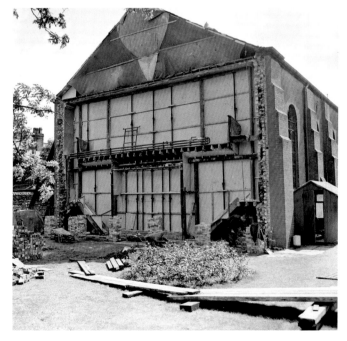

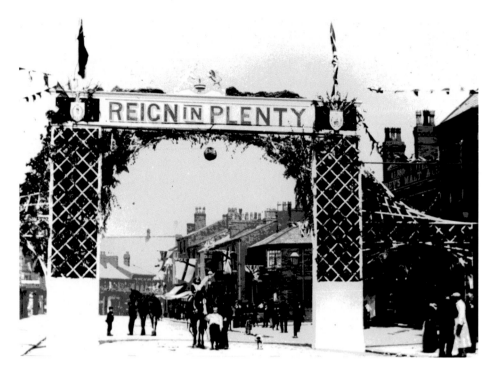

Arch Across Bolton Street

This temporary wooden arch is across Bolton Street, close to the Albion public house, which is visible to the right-hand side of the photograph. To the left of the picture was Back Street, which led to the fire station and slaughterhouse. In the centre distance, we look towards Market Street. The tall roof in the distance is that of Market Street Chapel. Above the roof is the chimney of Dole Mill. The arch was erected by local men as a tribute to their Majesties King Edward VII and Queen Alexandra on their coronation in June 1902. Today's view shows few changes have been made to the buildings to the right.

Duke Street

Looking up Duke Street, we have the junction with Bolton Road in view and Lyons Lane visible in the distance. The photograph probably dates from about 1910, after the original random stone-built houses had been faced with brick. The garden houses on the left were the most recently built. Interestingly, the road has still to be made up, there is only a short stretch of pavement laid out and the field on the right side still has its rural fencing in place. My aunt, uncle and cousin lived at no. 50, the house immediately to the left of the lamppost. Today's view shows how little these houses have changed; even the houses on the right side of Duke Street today have been there for almost a hundred years!

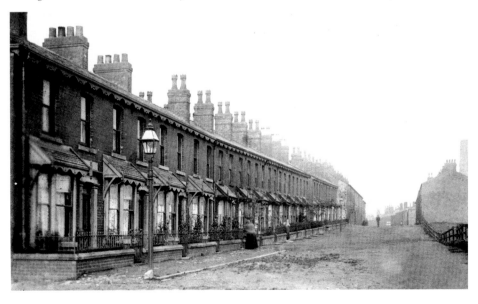

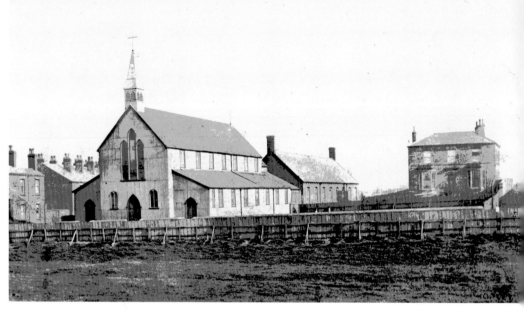

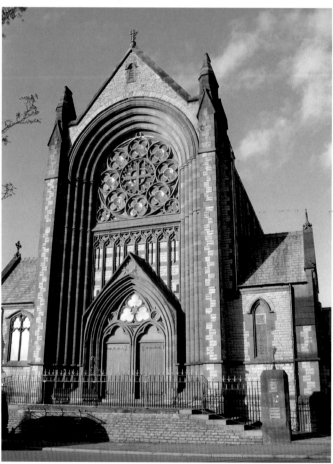

The Tin Church of Sacred Heart

Only a halfpenny stamp for postage was required for this old postcard with the view of a 'portable' or temporary Sacred Heart church! Such churches were made of wood and prefabricated sections fixed together on site and were moved to different towns, having served their community well until a permanent church was built. Our temporary 1875 church was replaced by the red sandstone Sacred Heart church on the same site in Brooke Street in 1895. The south front of the church forms an impressive sight. It narrowly missed being hit by German bombs that fell close by in the war. The terraced houses on the left are in Cuerden Street, to the west of today's Grade II listed church.

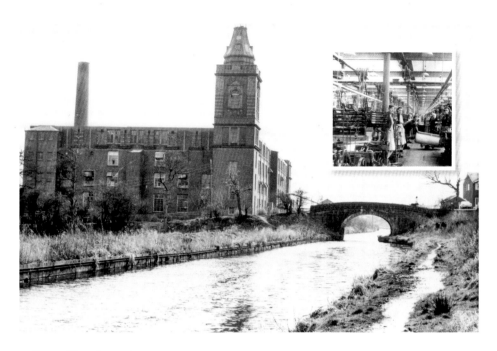

Talbot Mill and Canal

The largest cotton mill in Chorley (and in the county) was Talbot Mill, built in 1906, which had four floors for spinning and one for weaving. The weaving shed (see inset) contained 1,700 looms. The mill was to the east of Chorley, between the Leeds-Liverpool canal and a stream now called Black Brook. Originally Baggin Brook, with the surrounding fields being known as the Ley, the mill acquired its other name of Bagganley Mill. However, the official name of Talbot has historical connotations, for a 'talbot' was a hunting dog and the mill was built within the bounds of the Royal Forest of Healey, used for hunting in the fifteenth century. The spinning mill and its tower were demolished in 1992, and the weaving shed in 2002. The author worked alongside the demolition contractors, recording its demise.

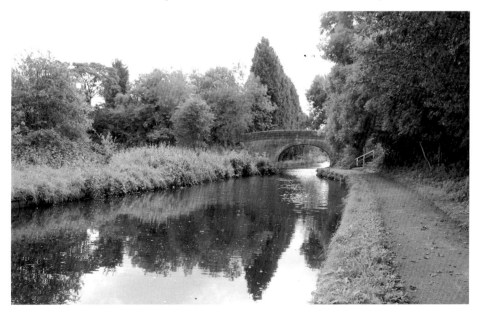

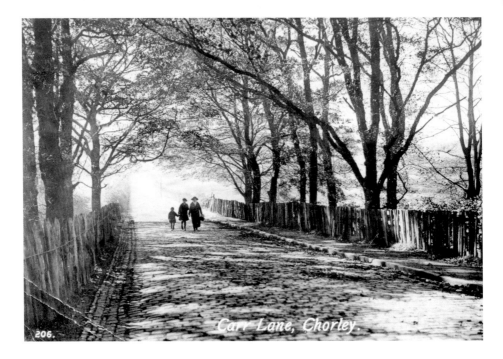

Carr Lane

Chorley's Carr Lane runs south from the west end of Pilling Lane to Yarrow Bridge on Bolton Road. It was an old right of way dating from turnpike days. It ran via Hoggs Lane to Cowling and Limbrick eastwards. Carr Lane, as it became, crossed the turnpike road at Red Bank. This old 1920s postcard view was taken close to the end of Hoggs Lane at Bolton Road. To the left, the walkers would be able to see the bridge over the River Yarrow and the river itself. Today's photograph, taken from almost the same location, illustrates how a formerly pleasant area has changed due to housing development, like so many others in Chorley Borough.

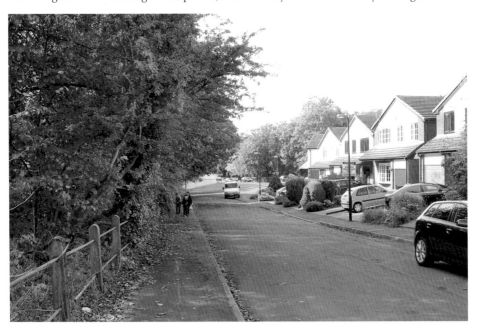

Spa Buildings, Hoggs Lane

How many people know that Chorley might have become a spa town? There's food for thought! Chorley's railway station had a notice on the platform saying 'Alight here for Whittle Springs'. The springs discovered in Dark Lane, Whittle, became so popular that a hotel was built to accommodate visitors coming 'for the waters'. The hotel later became known as the Howard Arms. But there was also another spring that for a short time in the mid-1800s might have become as popular: the mineral springs at Yarrow Bridge. Found by accident while boring for coal seams, the site was in Hoggs Lane, where a large house was built with ample outbuildings and a bathing pool. Today, the house and the pool outline remain. The Howard Arms has become an apartment complex and the Hoggs Lane Spa House is a private dwelling.

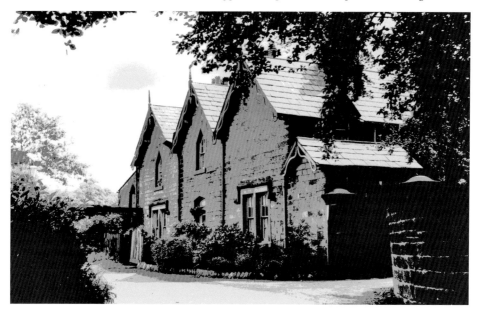

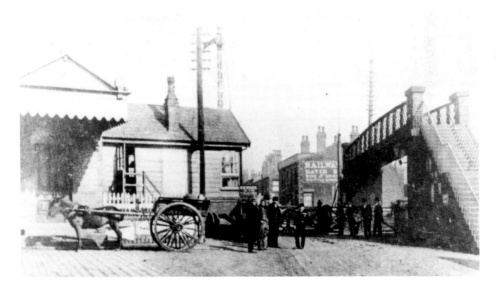

Railway Station Footbridge

Chorley railway station was originally sited in Railway Street, where the former goods yard offices used to be. This was the original terminus at Chorley, when the Bolton-Preston railway was under construction 1840–1842. The current railway station was built in 1843 when the line was opened to Preston and no longer a terminus. During the nineteenth century, gates were fitted for pedestrians to cross the line from Chapel Street to Steeley Lane, taking their lives in their hands as they did so. Several deaths occurred, and the bridge, as shown in the photograph, was built to safeguard pedestrians. However, this bridge was often boycotted, with the result that it was dismantled and a subway replaced it. The crossing gates were controlled from the box visible above the cart but were removed in 2009. Today's photograph shows the changes, including Chorley's town centre bypass which crosses in the foreground.

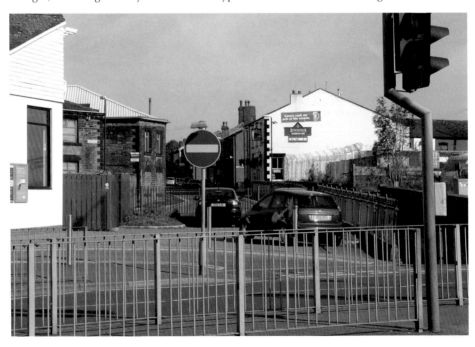

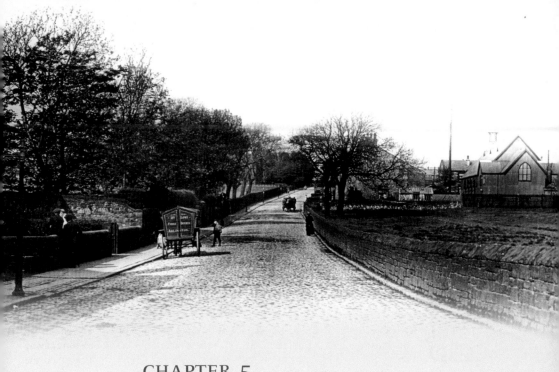

CHAPTER 5

Chorley Borough Villages

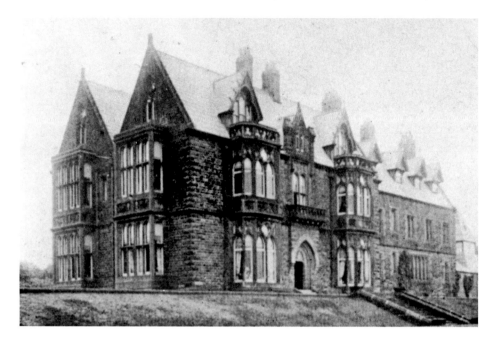

Anderton

Anderton township lies north and east of a curving stream, which is the infant River Douglas that rises on moorland to the east. The M61 service station in Anderton was opened by the Queen in 1969 and since then has shown travellers that Lancashire is not all factory chimneys! Since the boundary changes of 1974, Anderton is the first parish in Lancashire that one passes through after crossing the River Douglas. The Andertons of Anderton were lords from early times. In around 1830, when the male side of the family died, the female side married with the Stonors, and a new Anderton Hall was built, prefixed with 'Stonors', on land looking to Rivington Pike and the moors. This hall was demolished in the 1930s. Heraldic stones were rescued from the old site and moved to build into a wall close to Rivington Hall in 1978 by the late J. Rawlinson, J. Shaw, W. Snow, J. Priestley and the author.

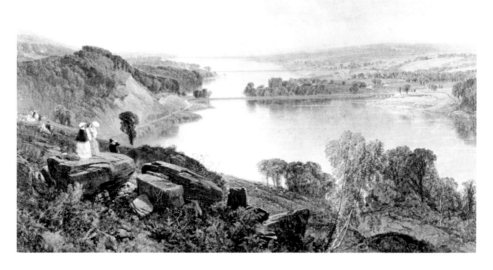

Anglezarke, Reservoir

This old view is from a painting by Frederick William Hulme (1816–1884). It shows three reservoirs. The nearest, called after its township Anglezarke. The other two are in the parish of Rivington, and named Higher and Lower Rivington. The parish of Anglezarke has lowland agriculture to the west. To the east is high moorland. Lead mining and stone quarrying took place between the two areas from the eighteenth century. The reservoirs were built from the 1850s by Liverpool Corporation, the moorland being a water catchment area. The reservoirs supply drinking water to Liverpool. The area is often described as being a 'mini Lake District'. Today's photograph was taken from almost the same location as the painting, at the top of a former quarry, now car park, famous as a viewpoint.

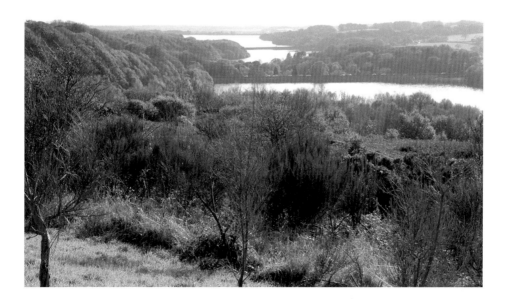

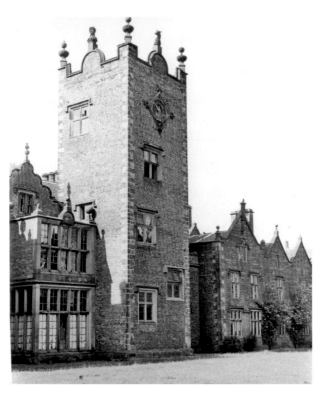

Bretherton

Bank Hall lies west of Chorley on flat agricultural land, formerly mossland. Through the village flows the River Douglas (or Asland), joining the River Ribble at Hesketh Bank. The lords of the early Manor of Bretheron were the 'Banastres of Bank', their Bank Hall mansion was built in the seventeenth century. The hall has been allowed to fall into dereliction, despite being a Grade II* listed building. Attempts to save it have come to nothing. It was featured on the TV programme *Conservation* in 2009. The village is also famous for its association with Jeremiah Horrocks, the astronomer, who first witnessed the transit of Venus across the face of the sun. The old photograph, taken in the 1960s, shows the south façade and tower complete. Today the building is sadly falling down; its future restoration is sadly very much in doubt. It is hard to believe that the top photograph is the older, 1860s view, for the January 2012 view shows the tower enclosed with scaffolding. Desite this, the 'back' (north side) of the tower has collapsed.

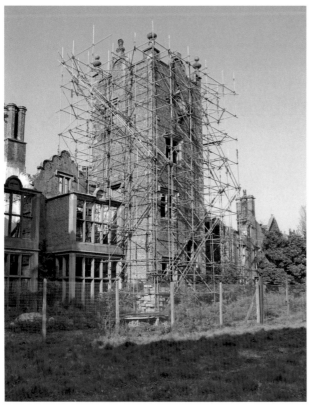

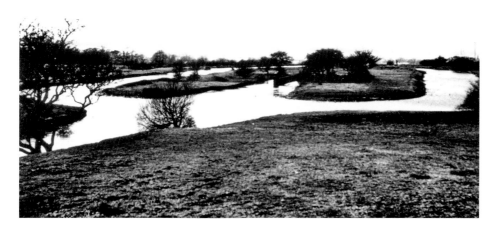

Brindle, Walton Summit Basin

Lancaster Canal was built in the 1790s, from Lancaster to Preston as its northern leg. Its southern section ran from the Wigan coalfields to Walton Summit, Brindle (and Clayton). Between the two ends of the canal a 'temporary' horse-drawn railway was built in 1803. Goods moved by canal and railway mainly comprised coal from the Wigan area, and Limestone from the north. All came via Walton Summit Basin. The southern section of the canal was drained and the basin levelled with the coming of the M61 Motorway in 1969. Today the site of the basin is part of Clayton Brook development, as shown on the colour image. Although the actual basin is buried, there is nothing on top of it, perhaps for some future archaeological dig!

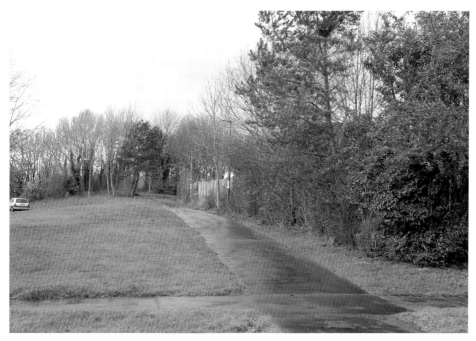

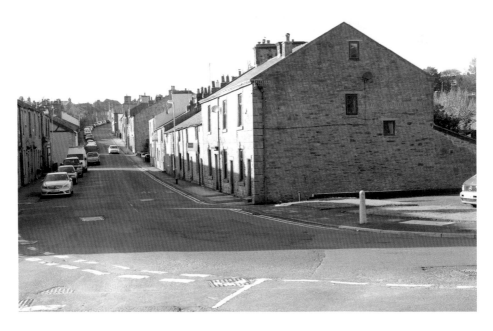

Brinscall, School Lane

Brinscall is a village lying close to the moorland hillside. It had a railway running through it until this was lifted in the 1960s. The railway served a bleachworks, quarry and wood yard, plus a cotton mill in adjacent Abbey Village. The village has benefitted from the association with Withnell Fold village mill owner Mr Thomas Parke, who provided a better water supply and sanitation to the village in the early twentieth century. The old photograph looks uphill along School Lane. The railway crossed the lane over the bridge. To the left, behind the houses, are Brinscall Baths, another benefit from Mr Parke, and one that is still in regular use. The block of shops to the right was converted into a small cinema. Today the railway bridge and cinema are gone, but the baths and the bleachworks water lodge remain, a Mecca for 'duck feeders'!

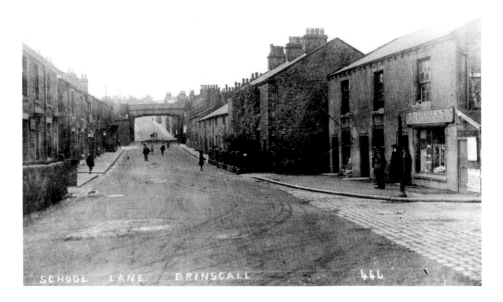

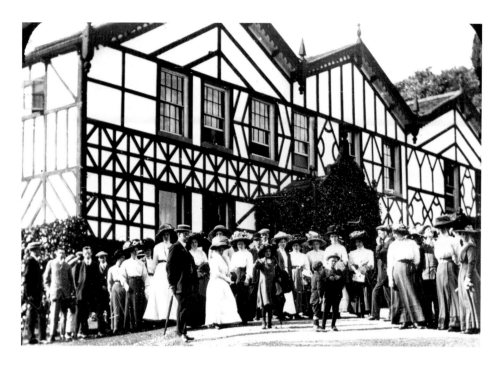

Charnock Richard... Park Hall

Charnock Richard is probably best known since the coming of the M6 motorway in the late 1950s, and the service station here. Close by is Park Hall, shown in our old view, about 1900, when privately owned, the people may be attending a function, much as they do today. There is mention of a hall in the sixteenth century but no trace remains, following rebuilds. In the 1960s and '70s, the hall was often on TV when top horse jumping competitions took place in 'Arena North'. The film *International Velvet* was partially made here (as audience extras, we had to hold up rows of cardboard people!). Arena North gave way to Camelot Theme Park, which also gets TV advertising. Today's picture shows part of the rebuilt hall, in the same style as the old building.

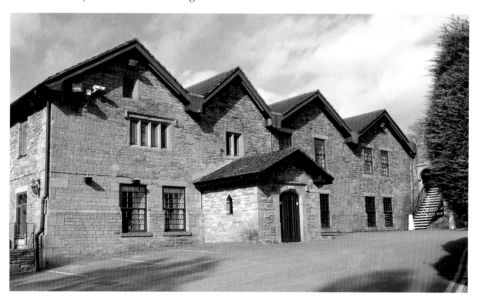

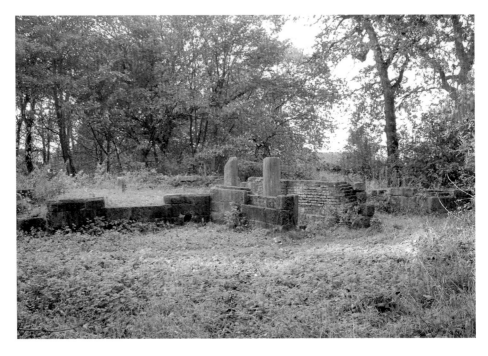

Clayton Hall

Clayton Hall was a seventeenth-century building surrounded by a moat. It was the home of the Clayton's of Clayton. The original building is likely to have been of timber-frame construction. The building as seen in the 1950s photograph was a farmhouse. The 1970s saw the house purchased by a developer who removed stone door jambs, lintels, mullion windows and beams from this listed building, to use at Park Hall. This led to vandalism and demolition. After years of campaigning, the site was cleared of rubble to create a 'consolidated ruin'. Today the moat exists and some foundation walls remain. The present day view was taken looking in a similar direction as the old, with the stone door post visible where the porch entrance was.

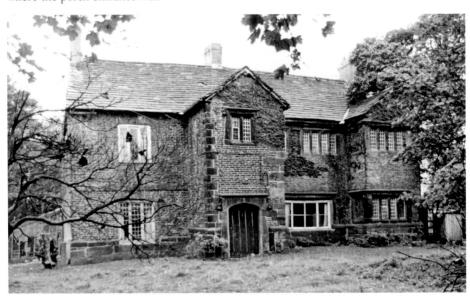

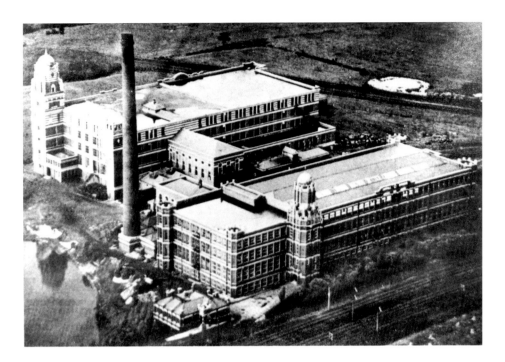

Coppull Mills

Coppull was never a 'cottonopolis'. Its business was generally agriculture, coal mining and sand quarrying. The early twentieth century saw two multi-storey spinning mills built, close to the main West Coast Main Line railway. The Mavis Mill, to the left of the old photograph, spun yarn using mules; the mill to the right was Ring Mill, using the ring spinning process. The two mills had one common chimney but two separate engine houses. Mavis Mill was demolished in the 1970s, but Ring Mill worked into the mid-1980s. This mill is now a listed building used by many separate unit businesses. It is an architecturally pleasing building with its yellow and red terracotta embellishment, as shown in this view across the mill lodge in 2012.

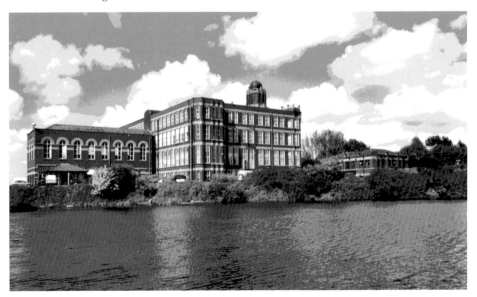

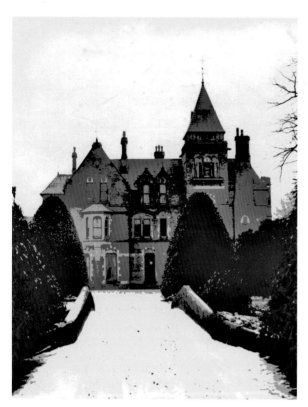

Croston Hall

The village of Croston has its roots dating back some seven or eight hundred years, when a cross was raised on the bank of the River Yarrow where a small church was built, to be upgraded and rebuilt over the centuries. The present parish church of St Michael's was built in the sixteenth century, with additions in the nineteenth century. A Dutch-style rectory is close to the church. Croston Hall was a gothic edifice erected in the nineteenth century by the squires of Croston, the De Trafford family. The hall was demolished in the 1960s. The old photograph shows the north front of the hall, across the stone-arched bridge, as viewed from Grape Lane gates. Today, only the parapets of the old bridge, dating from 1700, remain, with a modern wind turbine in the distance. The De Trafford family chapel of Pugin design is still in use today.

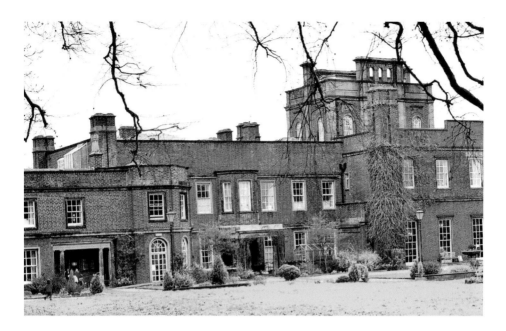

Cuerden Hall

Cuerden estate lies 5 miles or so north of Chorley, alongside the A6 and A49 Preston to Wigan Road. These were the only roads close to the hall parkland, until the M6 motorway was built. The route by Cuerden Hall threatened it with demolition, but it was eventually bypassed. However, two unusual gatehouse lodges and part of the park to the north of the hall were lost to construction. Here, in the 1960s, we see grading and preliminary drainage work underway in the former parkland. The early 1970s saw the hall and a new 'pavilion' annex used by the Central Lancashire Development Corporation (CLDC). The new M65 motorway also cut through the park in 1997. The hall became a Sue Ryder Home in 2000, as it still is today. The 2011 photograph shows the rear façade of the hall.

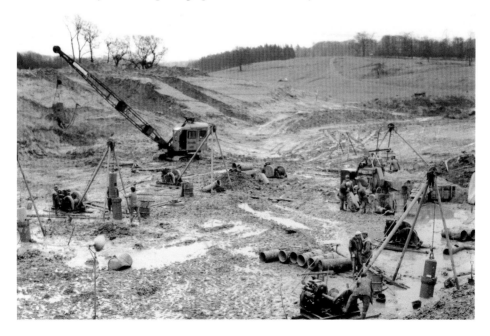

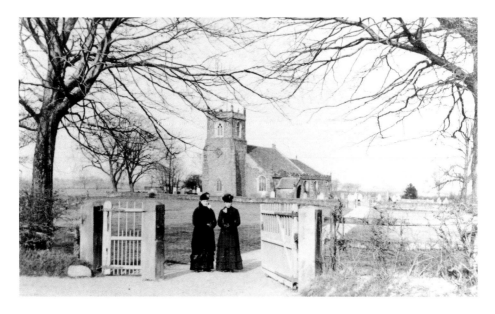

Eccleston

The parish church of St Mary the Virgin in Eccleston Village has its origins in the eleventh century (1094 AD). The picturesque sandstone church stand close to the south bank of the River Yarrow, which at times has overflowed its banks to flood the church and graveyard. The last major rebuild of the church took place in 1809. It still has its 'hearse house', which once accommodated the local hearse used for funerals, and a former gravedigger's 'bothy' has recently been converted into a parish meeting room. The old photograph, from about the 1900s or earlier, shows the church from the entrance gateway. Today a lych gate forms the gateway, and trees hide the church itself.

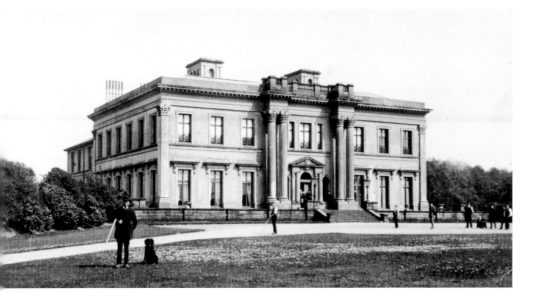

Euxton

A village with a name pronunciation problem! The difficulty cropped up in 1936 when the government decided to build a Royal Ordnance Factory in the village, but called it 'ROF Chorley', not 'ROF Euxton'. Even Lord Haw Haw of 'Germany Calling' radio used to get the name wrong. And he lived locally in the 1930s. Euxton hall, shown in sepia, was originally a timber-frame building, rebuilt in 1769 and again in 1850. Charles Stuart (Charles II) visited the hall, and while out riding drank water from a stream. Legend has it that he said 'it is a cool beck' and through time this became 'Culbeck'. Now it is known as Culbeck Brook. The hall was the home to a branch of the Andertons from the seventeenth century. A fire destroyed the upper floor and the hall was rebuilt as a bungalow. This is now the entrance to Euxton Hall private hospital.

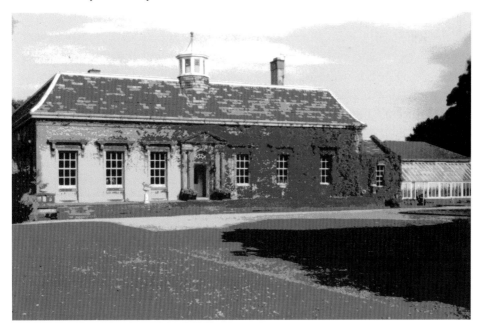

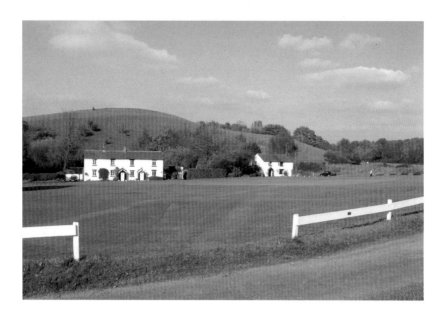

Heapey (White Coppice)

Heapey parish lies close to high moorland to the east, where evidence of prehistoric occupation of 3000 years is found. Water from the moors runs into reservoirs at Anglezarke and Rivington. Overflow water is fed into water lodges, once used by local industry to process cloth by bleaching and dyeing. The area is popular with walkers, anglers and natural history enthusiasts. Between the streams and water lodges is a cricket field. A location with superb views, a 'must visit spot', within the county. The cricket team members are from the Chorley area generally. A few years ago the field was featured in a BBC television children's series called *Sloggers*. Today's view looks across the pitch, unfortunately without a game in progress, for it was taken in October 2011. The older view compares the area in winter snow, with a few differences though.

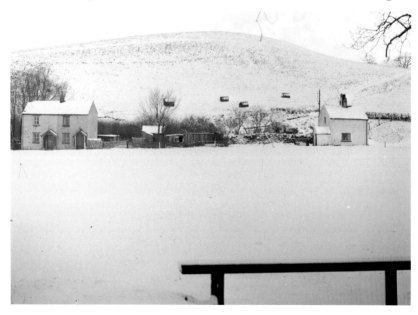

Heath Charnock

Due to its rural location, in 1901 an isolation hospital was built here, for the treatment of Scarlet Fever, Typhoid, Smallpox, etc. The administration offices are shown in this 1950s view. It was a place where as boys, we were told to 'keep away from' by our parents. This of course was interpreted by twelve to fifteen year olds in the 1950s to 'go and find out ourselves'. And we did! It was a place where fresh air was a cure. There were rows of small sheds which could be turned into the wind with beds inside, so the patients could be wrapped up and left in their respective shed for a while. At least the hopital's location had open views to the high moors and Rivington Pike Hospital reorganisation in Chorley in the 1990s led to the demolition of Heath Charnock Hospital.

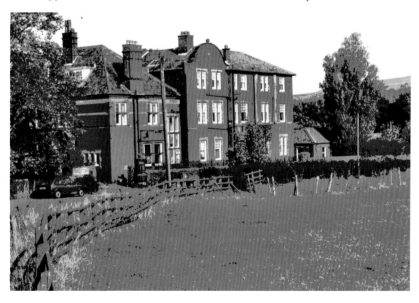

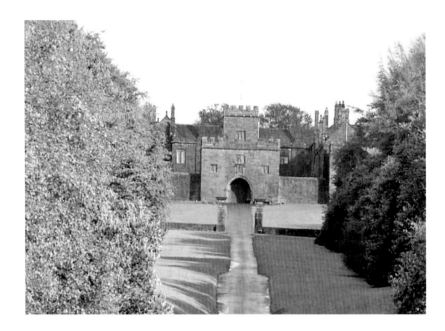

Hoghton

The township of Hoghton is undulating, and of an agricultural nature. There are two separate communities here, close by a mound shaped hill rising to 550 feet. On top of which, Thomas de Hoghton built a large defensive eminence called Hoghton Tower in 1564. Richard became the first Baronet in 1611. In 1617 he entertained King James here, on which occasion, allegedly, the King knighted an excellent loin of beef, calling it 'Sirloin', a name which has lasted through time. There is too much history associated with the tower to discuss here in detail. Suffice to say that it was involved with the Civil War, and that William Shakespeare and Charles Dickens are just two of its distinguished visitors. Following a period of dereliction the tower was restored in 1901. It is now open to the public for tours and other functions. The Sealed Knot Society regularly holds re-enactment battles close to Hoghton Tower.

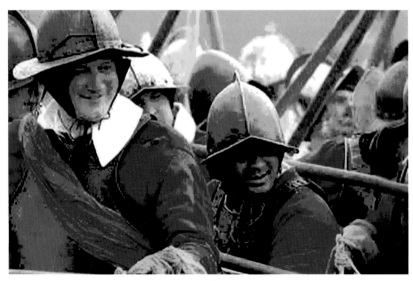

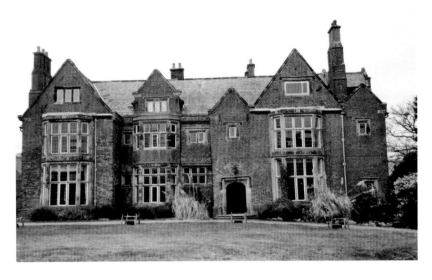

Heskin

Another of Chorley's scattered villages, historically Heskin's economy was mainly agricultural, but it had limited sand extraction in some areas and a large stone quarry. In later years the quarry gained notoriety when the 'handless corpse' murder victim was discovered here. Syd Brook passes through the township. A water mill on the brook was sited at Whittle Bottoms. The village has its share of old buildings such as the cruck-framed Stanley Wives Farm. The principal mansion here was the home of the Molyneaux family. The original manor house was burned down in the sixteenth century and a new house built a short distance away. Heskin Hall is an attractive building with decorated brickwork and other embellishments. The hall is used today as an antiques centre. The 'home farm' to the hall has had a large shopping complex added of late, which also uses some old farm buildings.

Mawdesley

Mawdesley village lies some six or so miles south-west of Chorley and is now within the postal district of Merseyside, but the village borders the administrative area of West Lancashire, based in Ormskirk, and has its telephone numbers in the Southport directory! Agriculture features highly in this rural location. The village was famed for its woven wicker basketwares. Many of the workshops were scattered around the village. It was a 'hands on' industry, employing many people to harvest the willows and process them by stripping etc. Mawdesley basketwares were sold at many markets in the county. The old picture shows a group of basketmakers outside their workshop. The last local individual to produce basketwares here died a short time ago. Nowadays, traces of the willow plantations remain, never to be harvested again for their twigs. Basketwares are still sold locally, but not locally produced.

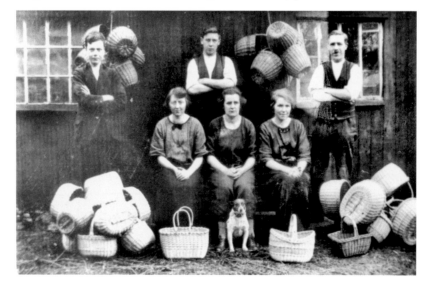

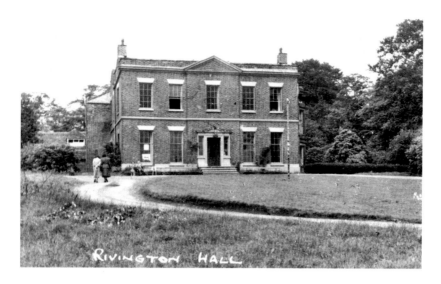

Rivington

The village has many attractions for its thousands of annual visitors. It lies close to the West Pennine Moors, with views to the Lake District mountains, the sea coast and the Isle of Man to the west. The high moorland above the village rises to Winter Hill, known for its television transmitter, built a short distance from sites of prehistoric burials. Lord Leverhulme, the soap magnate, built a summer bungalow with extensive terraced gardens here, and gave land to become a people's park, now Lever Park. In this park are two cruck barns of seventeenth-century or earlier date, both used as visitor centres for refreshments and functions. There is also a full-size replica ruin of Liverpool Castle, built by Lord Leverhulme. Rivington Hall was the home of the Lords of Rivington from early times and has had several rebuilds. A 1950s and a 2012 view of the hall are shown here.

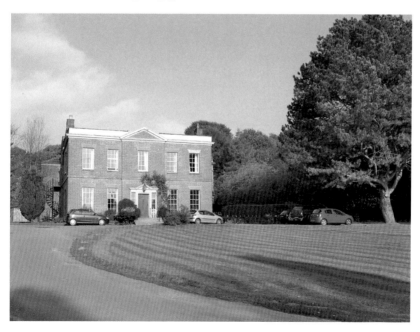

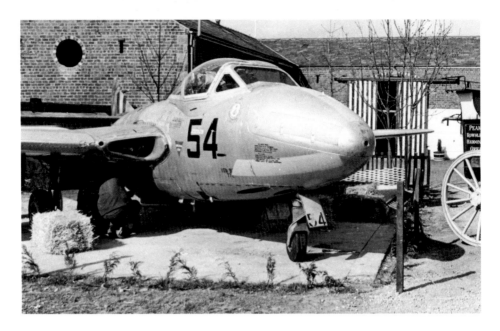

Ulnes Walton

Described locally as 'a village without a church', the village comes under the parish of Croston. The 1930s, saw farmland compulsory purchased to build a Ministry of Supply Depot. This site is now partly built over two of Her Majesty's Prisons. The remaining part of the site is under investigation by the author, recording what remains of this wartime depot. The Preston to Ormskirk railway passes through the village, with sidings to a former brickworks at Littlewood. There was a 'museum' of bygones here in the '60s and '70s, called the Royal Umpire Museum, which had examples of old rural ways of life, and stagecoaches from the turnpike days. A late exhibit was a Vampire jet plane – out of context perhaps, but interesting nonetheless! Today the museum site is for residential caravans. The Mill hotel, shown in today's picture, is sited where the jet plane used to be.

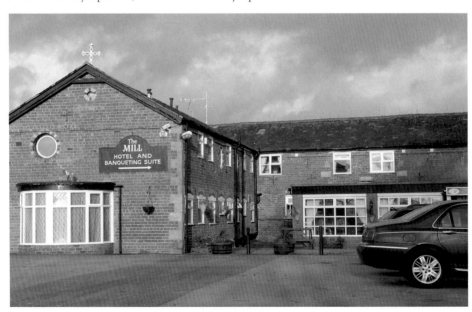

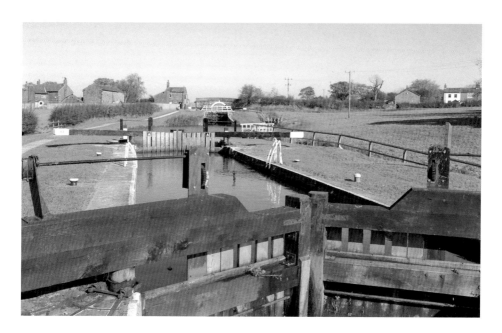

Whittle-le-Woods

This township was famous for its manufacture of millstones. The Lancaster Canal was cut through the village in the 1790s, with problems being met while tunnelling through Whittle Hills. The Lancaster Canal southern section terminated at Walton Summit in a multi-arm basin (see page 77). The Leeds to Liverpool canal arrived at Whittle in 1816, to join 'the Lancaster', which was leased from the Lancaster Company from Whittle to Wigan. To join the Lancaster Canal at Whittle Springs, the Leeds Canal had to lock down via six sets of locks. The Lancaster Canal section was drained in the 1960s due to the building of the M61 motorway. The Johnson's Hill locks are shown in both photographs here. The 2012 view above is at the same lock, but both gates are closed.

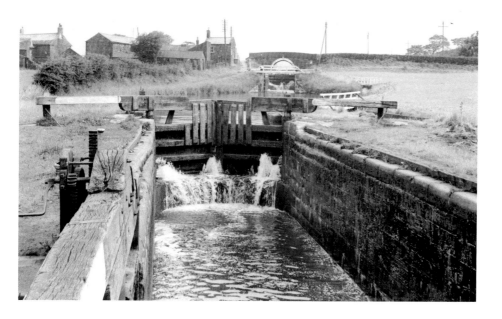

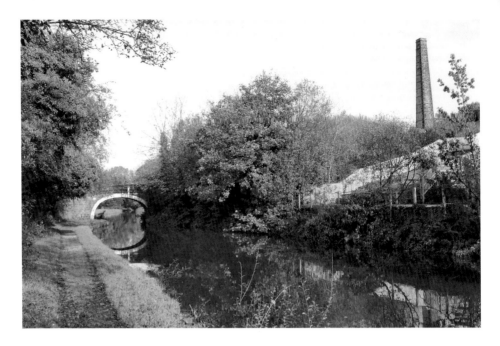

Withnell Fold

This small village within the wider district of Withnell was built alongside the Leeds to Liverpool Canal, where a paper mill was built, plus housing, a school and a chapel. A community bathhouse and club were added later. The mill and village were built in the 1840s by Thomas Blinkhorn Parke, who was a great benefactor to the area. The mill came under the ownership of the Wiggans Teape Company from the 1890s. Banknote paper was one of the fine grades of paper manufactured here until its closure in 1967. The paper mill 'wet end' site is now built over with new houses. The packing and dispatch end of the mill survives as industrial units, with the tall, square mill chimney. The old photographs show the 'wet end' of the paper mill, by the canal in the 1930s. Today trees and new houses replace the mill.

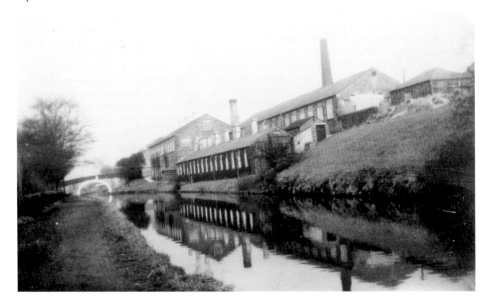

Royal Ordnance Factory Buckshaw Village

The minor hall of Buckshaw was built in 1688 by Edward Robinson in the timber 'box frame' style. The land was purchased from the Andertons of Euxton Hall. The house had become Buckshaw Hall Farm by the 1930s, farmed by the Stock family. In 1937 the government purchased land to build the Royal Ordnance Factory, which was opened by King George VI in 1939. It became the largest explosive filling factory in England – a 'second Woolwich', as it was nicknamed. By 1998 the factory was running down to closure and demolition had started. From the rubble of this famous factory where the 'Dambuster' bouncing bombs were filled with explosive, a new village has arisen, referred to as the largest building site in Lancashire. The village now comprises domestic housing, industrial buildings, warehousing and a brand new railway station, which opened in October 2011. The author was co-writer/advisor on the book *A History of the Royal Ordinance Factory, Chorley*.

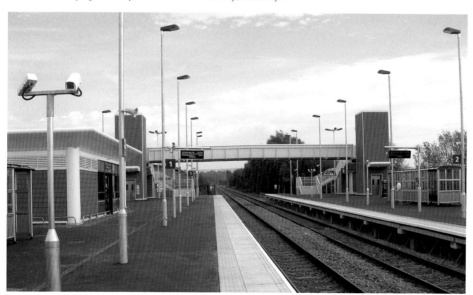

Wheelton

The village of Wheelton is split into two communities, that of Higher and Lower Wheelton. Lower Wheelton saw a large multi-storey cotton mill built in the early twentieth century by Peter Todd. There were handloom weavers' cottages in the village, and a war memorial clock tower was built at the village centre in 1922. The photograph shows the approach to Lower Wheelton in the 1940s, the turning to the left descending to the village centre. A landslip in the 1960s, beyond the village on the Higher Wheelton/Blackburn Road, saw a bypass road built continuing the line of this old road, to pass the gable end of the row of cottages in the distance.

Acknowledgements

In the research and preparation of this work, I would like to acknowledge the help and co-operation of the following persons, companies and organisations for allowing me access to photographic material and locations to obtain the photographs needed:

Former early local photographers in Chorley, Messrs Luke Berry and Co., national postcard companies, many un-named. The *Chorley Guardian* newspaper and readers who gave or loaned prints from the newspaper. The late George Birtill OBE, fellow historian and colleague, for copy photographs. The late Alderman Charles Williams' photographic collection. The late J. Shaw, L. Chapman, T. Hull and R. Campion for photographic material. The late J. Rawlinson, T. Leach and J. Smith (all of Horwich) for information. Mr and Mrs J. Monks, Mrs M. Rawlings, Chorley Borough Council, Chorley Central Library and Network Rail. And to my partner Barbara for her knowledge of computer 'wizards' and their foibles, how to overcome them and how to remain sane despite them!

A big thank you for all your help and support.

Jack Smith